ESSENTIAL

FASHION

ILLUSTRATION

DETAILS

ESSENTIAL

FASHION

ILLUSTRATION

DETAILS

GLOUCESTER MASSACHUSETTS

ROCKPORT

PUBLISHERS

Copyright © 2007 by maomao publications
First published in 2007 in the United States of America by
Rockport Publishers, a member of
Quayside Publishing Group
33 Commercial Street
Gloucester, MA 01930-0589
Telephone: (978) 282-9590
Fax: (978) 283-2742
www.rockpub.com

ISBN-13: 978-1-59253-331-2
ISBN-10: 1-59253-331-0

Publisher: Paco Asensio

Editorial coordinator: Catherine Collin

Illustrations: Maite Lafuente

Introduction: Ana G. Cañizares

Art director: Mireia Casanovas Soley

Graphic design and layout: Anabel Naranjo

English translation: Bridget Vranckx

Editorial project:
maomao publications
C/ Tallers 22 bis, 3° 1ª
08001 Barcelona. Spain
Tel.: +34 93 481 57 22
Fax: +34 93 317 42 08
www.maomaopublications.com

Printed in Spain

Contents

Introduction 6

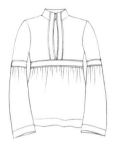

Shirts 8
Tops
Blouses
Vests
& Sweaters

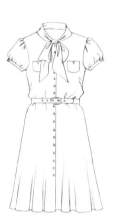

Skirts 52
Dresses
& Pants

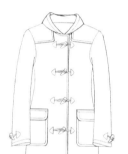

Jackets & Coats 104

Lingerie 134
Shoes
& Accessories

Details 182

Fashion Schools 192
Directory

Introduction

Among the many components of fashion illustration, one of the most fundamental is the expression of clothing designs as flat drawings. Despite their apparent simplicity, it is necessary to pay careful attention to certain details that are often overlooked in order to convey the desired shape, volume, and texture of a particular garment. At the same time, the flat drawing proves to be an easier method of illustration than that of drawing three-dimensional human figures, offering the illustrator an equally effective, faster, and less complex way of expressing their ideas. *Essential Fashion Illustration: Details* is perfect for those looking to polish their drawing skills or for those who find difficulty in drawing the human figure and are searching for the right tools to express their clothing designs on paper.

Covering an extensive range of garments including pants, skirts, dresses, shirts, jackets, swimwear, and underwear, this compilation of flat drawings provides a complete overview of the different varieties within each garment and features the styles that have been the most relevant throughout the history of the wardrobe. An essential part of any design, accessories like shoes and hats have also been included to aid designers in achieving the most complete design possible. Most important, however, the illustrations will serve as a reminder to pay attention to crucial details such as stitching, pleats, and wrinkles, which often make all the difference in lending a realistic character to a drawing.

Flat drawings, although perhaps less visually attractive in comparison to other techniques, form an indispensable part of fashion illustration. A basic and straightforward representation of a garment as a flat drawing is the first step in expressing an idea for a design on paper, and given their simplicity, must be executed with perfection in order to convey all of the qualities and characteristics of a particular piece. *Essential Fashion Illustration: Details* intends to provide those looking to develop their own drawing skills with a practical and useful source of inspiration that holds the keys to mastering the art of the flat drawing in the world of fashion design.

Ana G. Cañizares

Shirts
Tops
Blouses
Vests
& Sweaters

Shirts

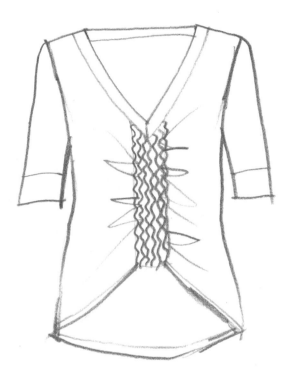

Shirt with smock stitch down middle

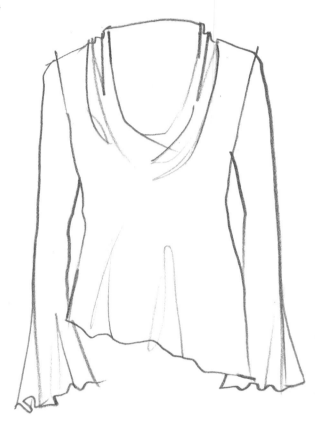

Draped neckline. Asymmetric drop. Wide-flared sleeves.

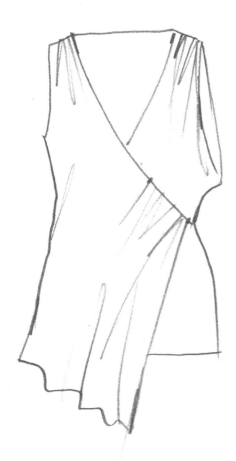

Asymmetric and gathered front. Gathered shoulders.
One sleeve with more gathered material.

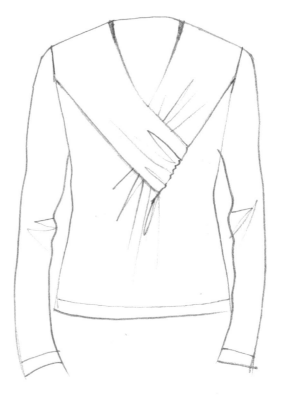

Shirt with draped traverse

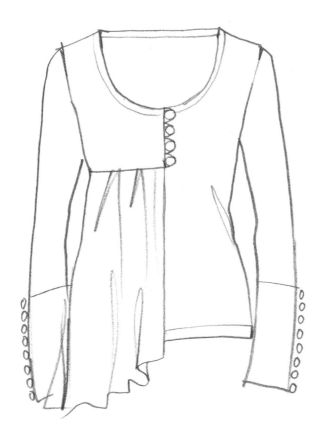

Two pieces of fabric: one fin, long and gathered below
the bust. The other compact. Button and loop closure.

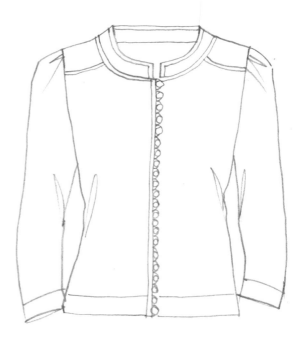

Shank neck, 3/4-length sleeves, button and loop
fasteners and gatherings at the shoulders.

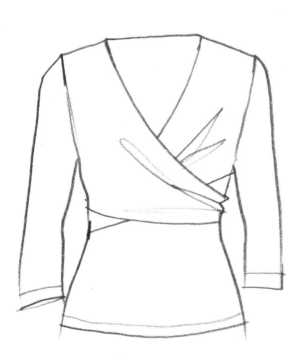

Draped front crossing

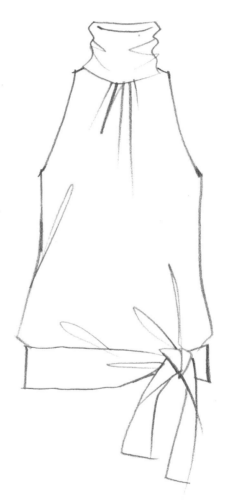

Gathered turtleneck. Low knotted waist. American armhole.

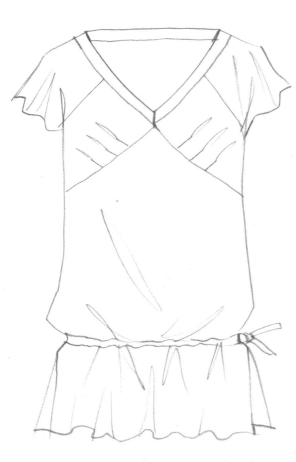

Tunic tucked at the hip and gatherings below the bust

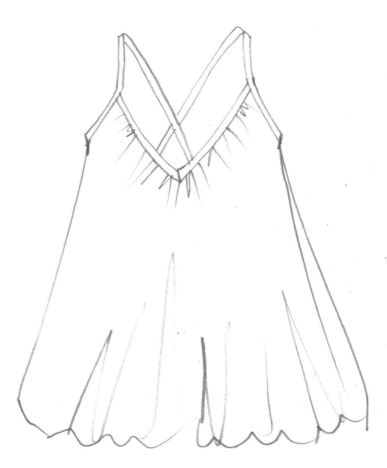

Ballooned with double fabric and gathered.
Crossed straps on the back.

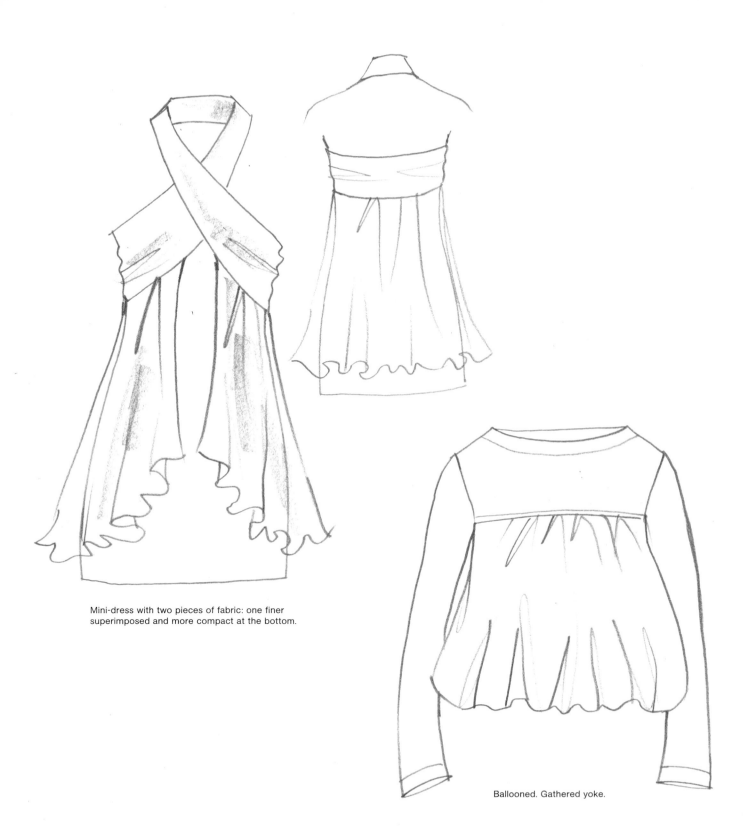

Mini-dress with two pieces of fabric: one finer
superimposed and more compact at the bottom.

Ballooned. Gathered yoke.

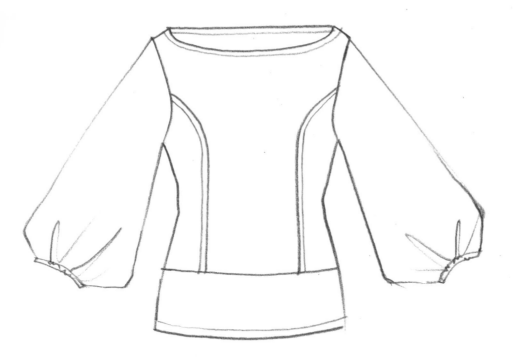

Scoop neck. Fitted at the sides and 3/4-length convex sleeves. Elastic cuffs.

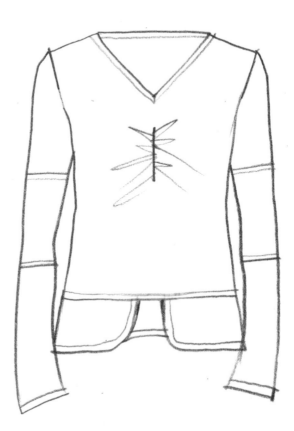

Gathered with elastic in the center of the garment

Tops

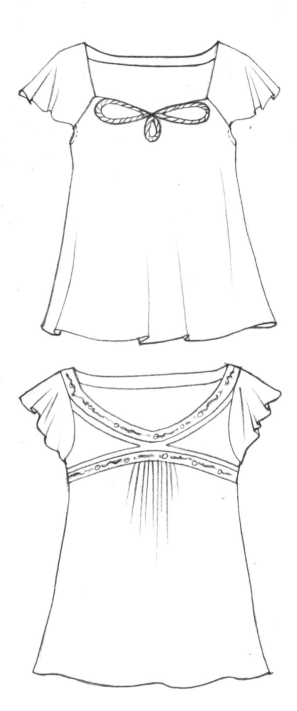

Flared tops with trimming

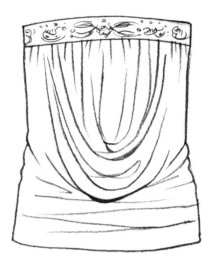

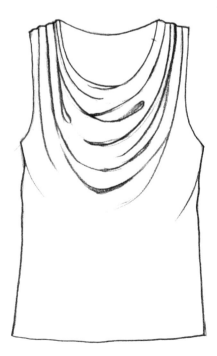

Draped tops

17

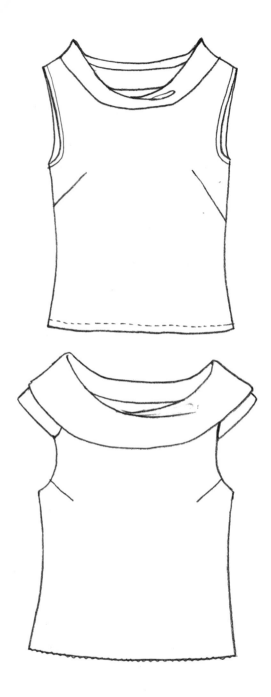

Tops with stretched collar

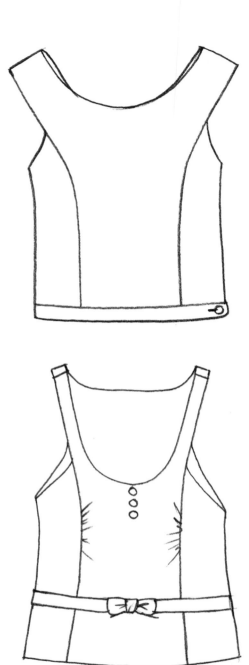

Retro tops with belt

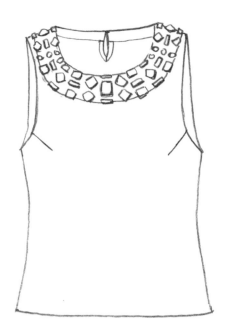

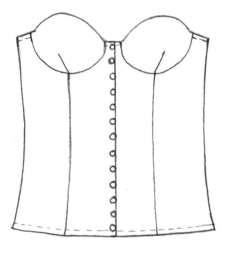

Bustier

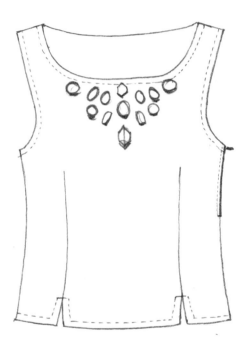

Beaded tops

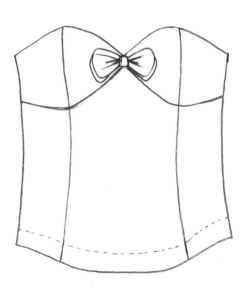

Bathing-style top

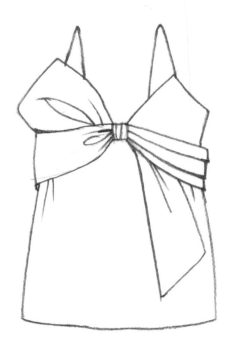

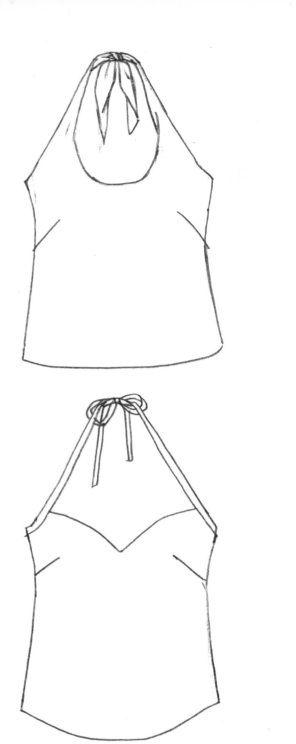

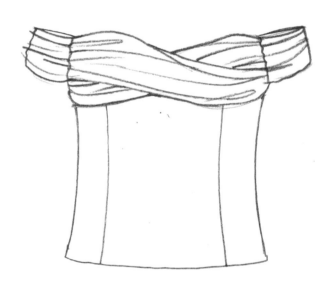

Tops tied at neck

Draped tops

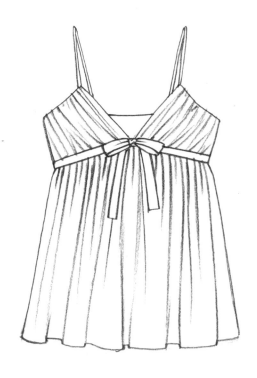

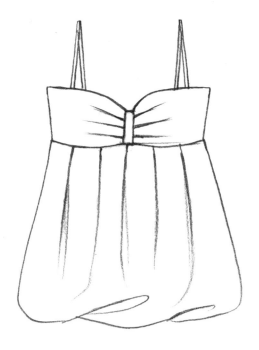

Balloon top with straps

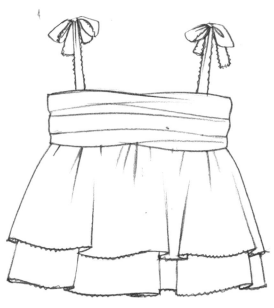

Empire-style tops

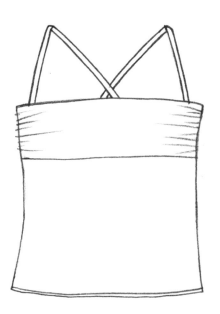

Top with crossed straps

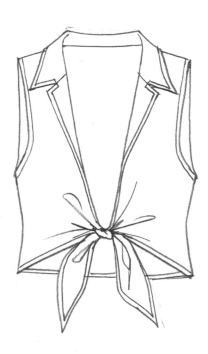

Knotted sleeveless top

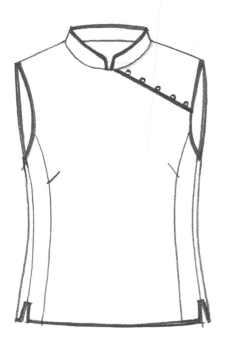

Chinese-buttoned top

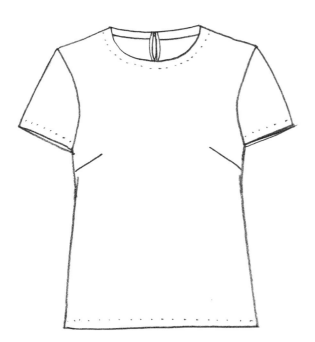

Crew neck top

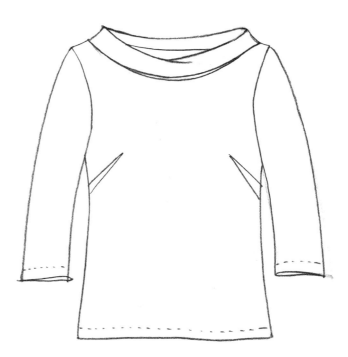

Top with stretched collar

Blouses

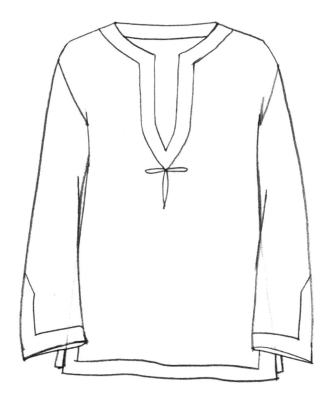

Caftan blouse

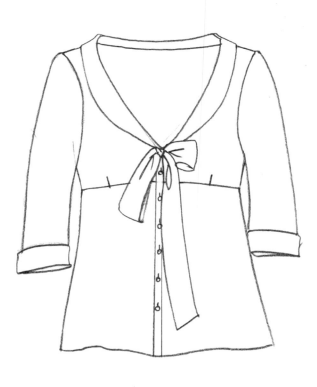

"Biarritz" blouse

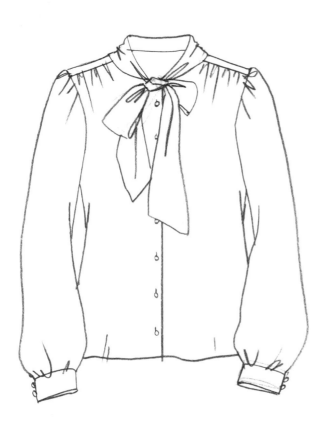

Tie-neck blouse

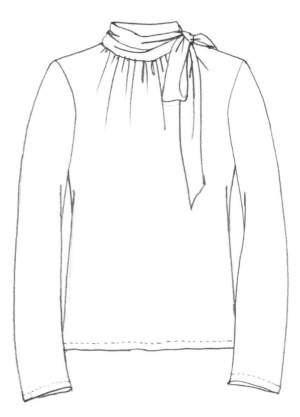

Blouse with tied collar

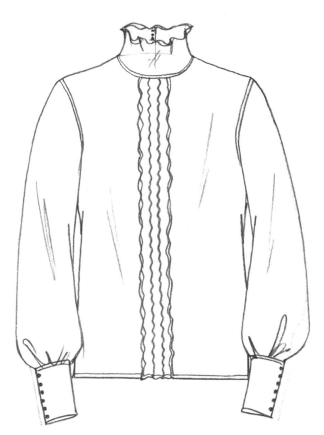

Blouse with Victorian collar

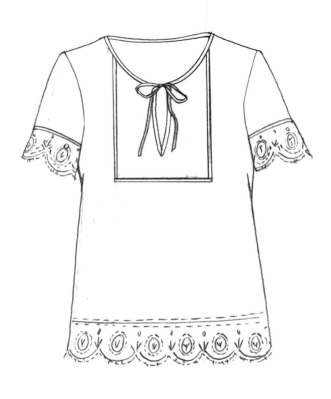

Lace blouse with shirt front

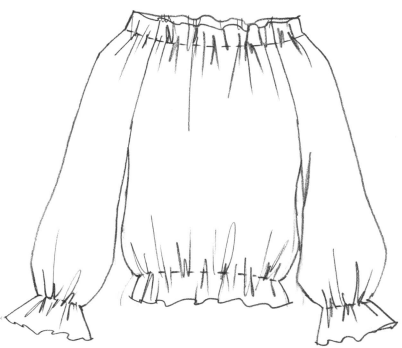

Smock

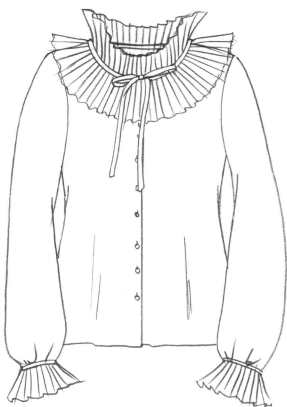

Blouse with ruff

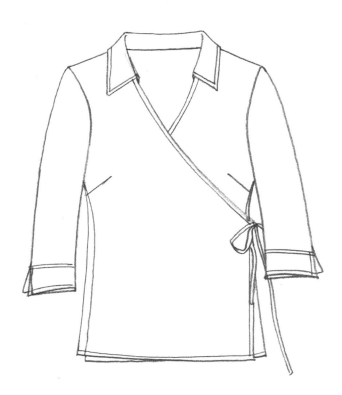

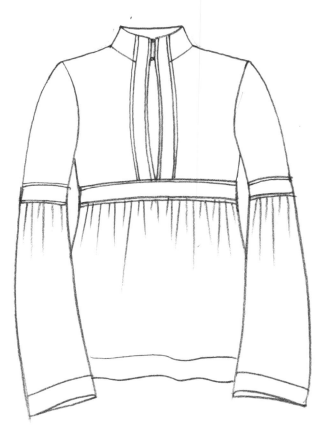

Wrap-around blouse

"Zingara" blouse

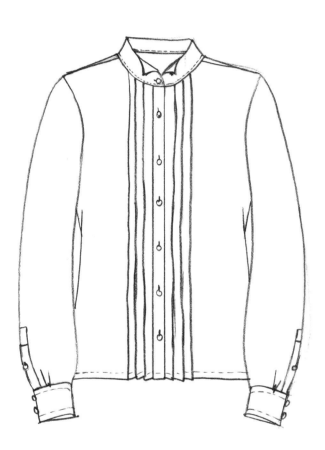

Bow tie blouse

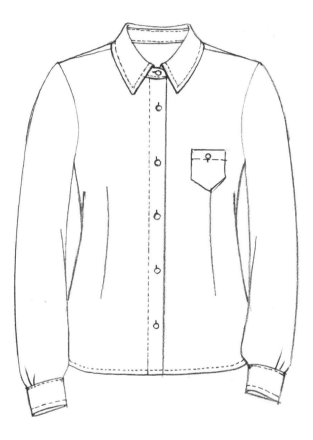

Classic blouse

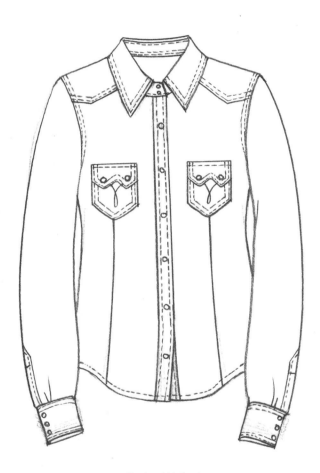

Denim shirt, *front*

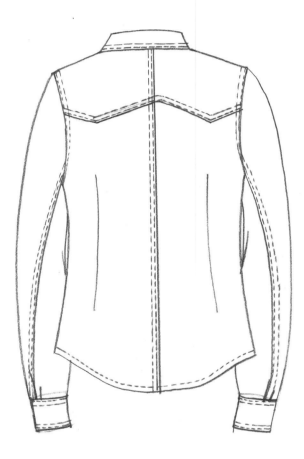

Denim shirt, *back*

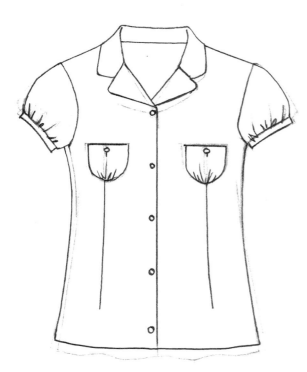

Retro blouse

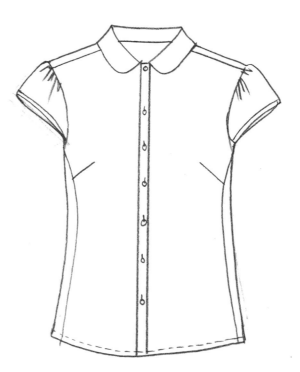

Round-collared blouse with gathered sleeves

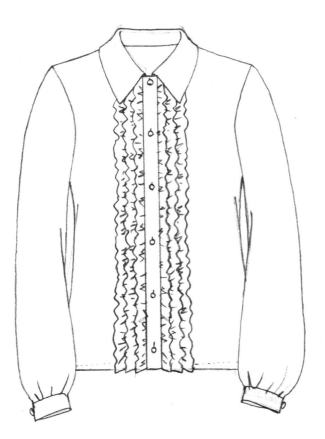

Ruffle-fronted blouse

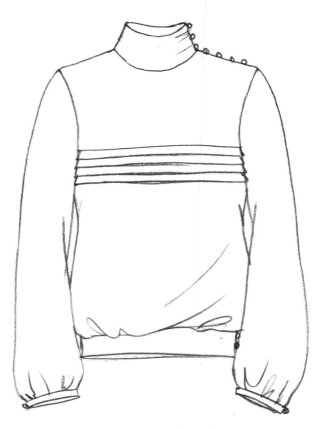

Buttoned blouse with pleated breast

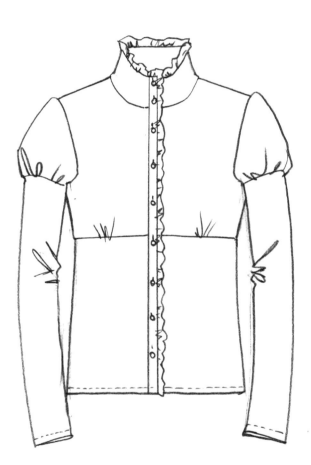

Victorian blouse

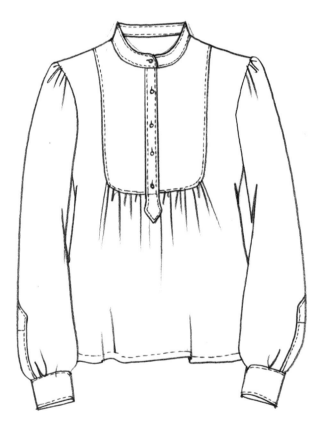

"Peasant" blouse

Vests

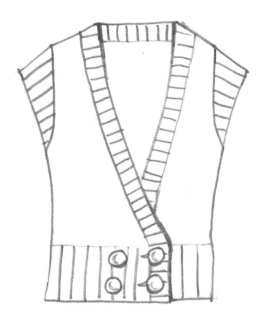

Thick double-breasted

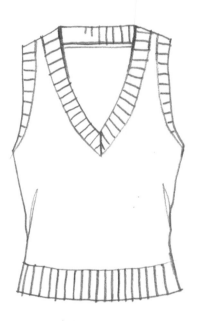

Closed with wide ribbing

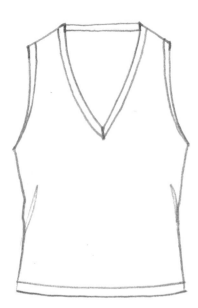

Closed and tight

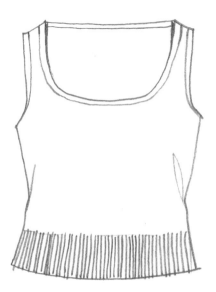

Low-necked

Sweaters

Low-necked with 3/4-length sleeves

Classic

Classic cardigan

Twin set

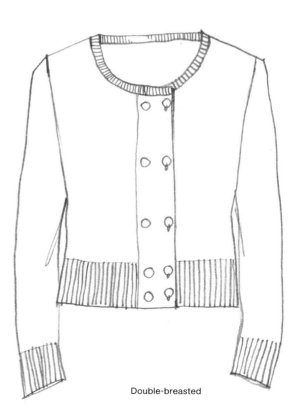

Double-breasted

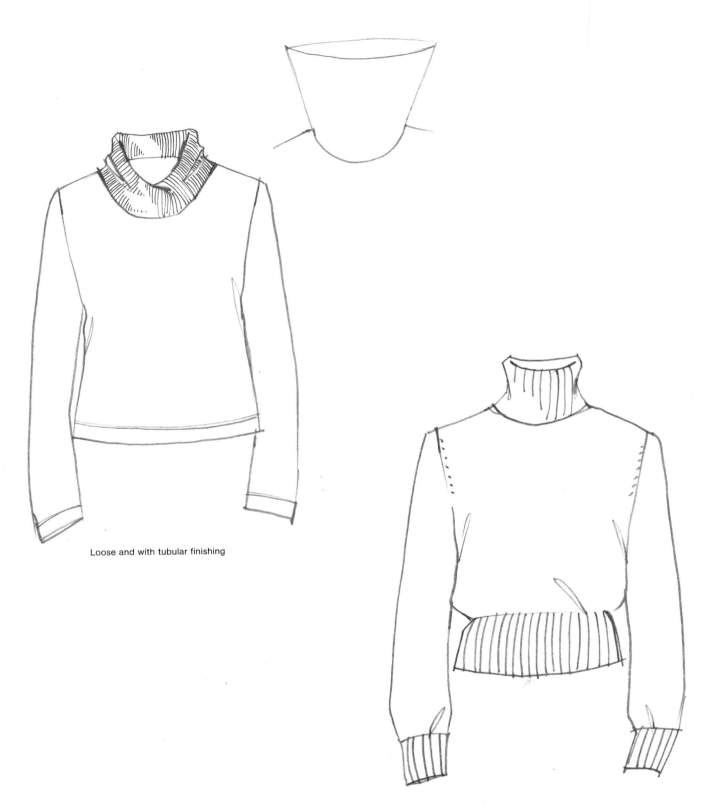

Loose and with tubular finishing

Classic thick turtleneck with wide ribbing on
bottom and cuffs.

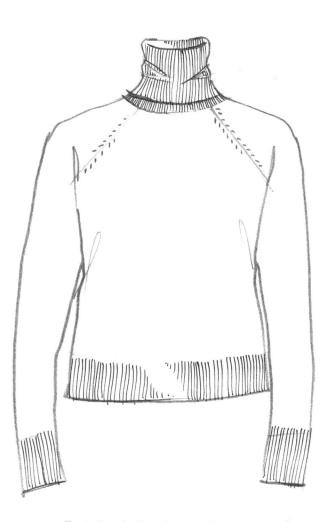

Fine turtleneck with raglan sleeve fashioning. Wide ribbing on bottom and cuffs.

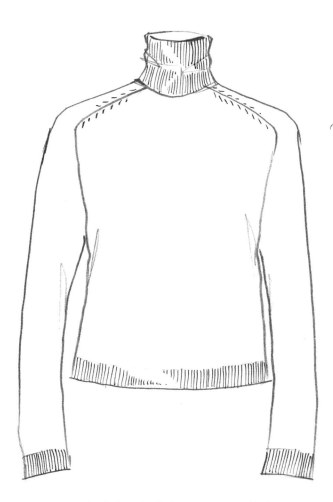

Fine turtleneck with hammer sleeve fashioning

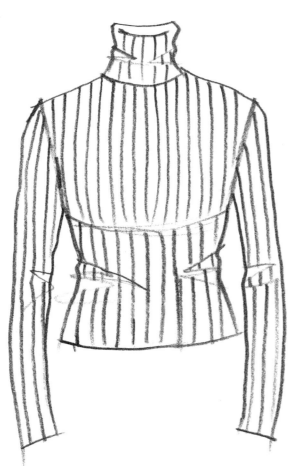

Ribbed turtleneck

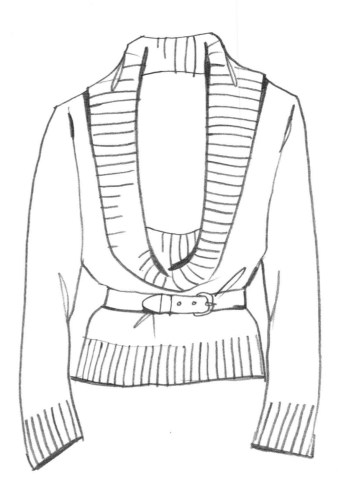

Thick turtleneck, loose and low neckline.

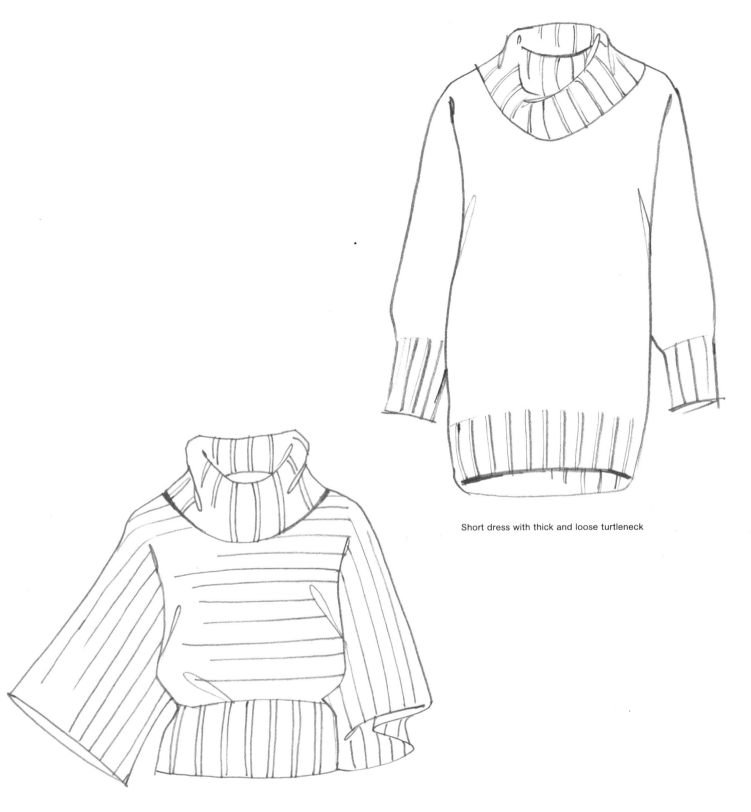

Short dress with thick and loose turtleneck

Thick turtleneck with 3/4-length Japanese sleeves

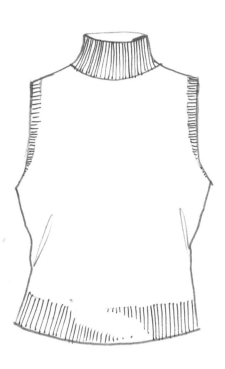

Semifine turtleneck. Sleeveless.

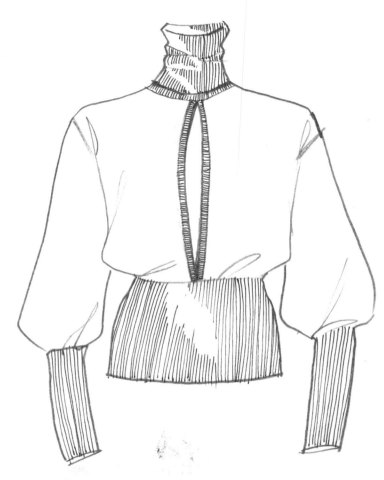

Fine turtleneck with middle parting. Bottom and cuffs very wide. Loose fitting line.

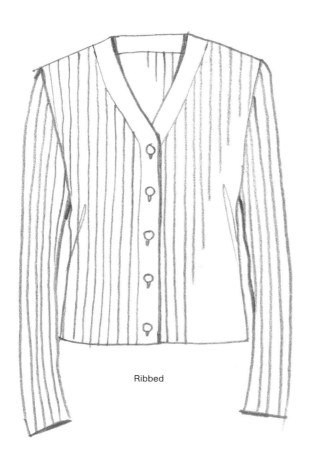

Ribbed

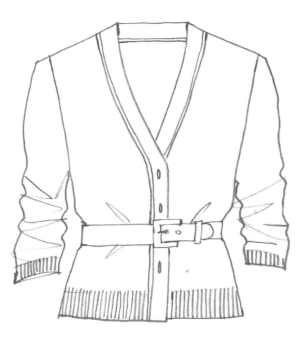

With belt, pushed up sleeves and flat strip

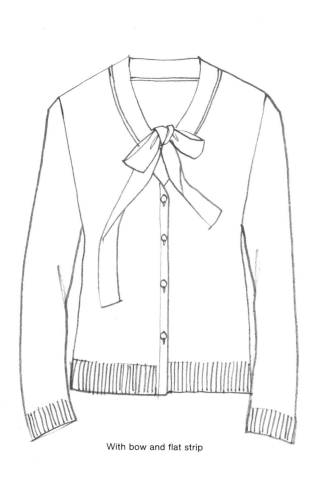

With bow and flat strip

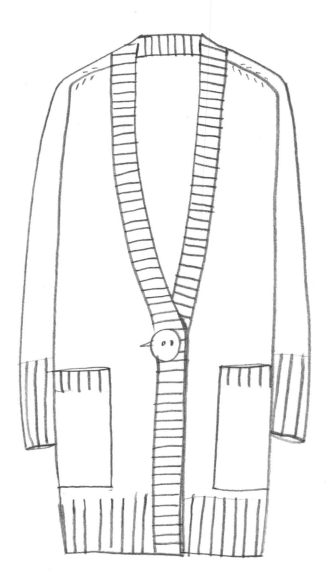

3/4 length and thick

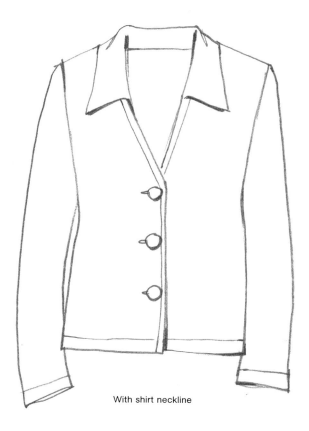

With shirt neckline

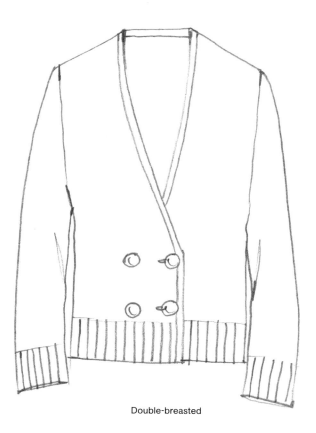

Double-breasted

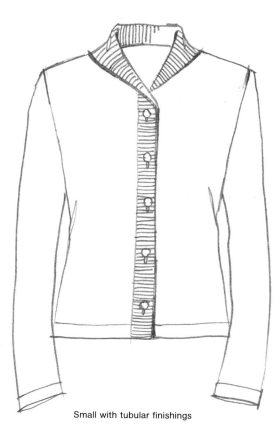

Small with tubular finishings

45

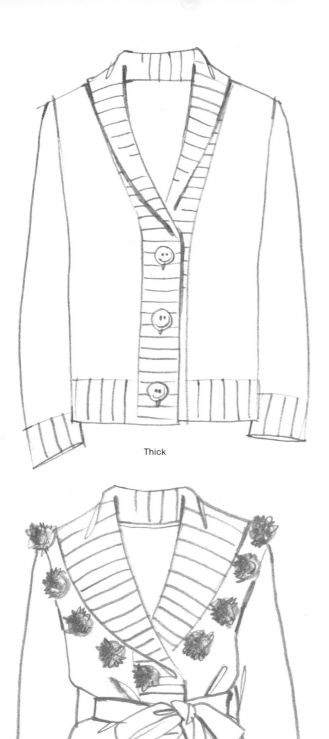

Thick

Fancy smoking cardigan with
pom-poms and satin bow belt.

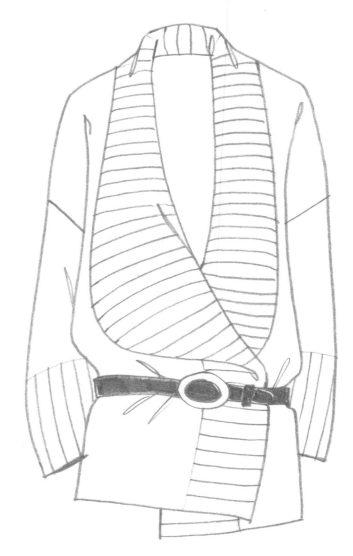

Very exaggerated finishings and unstructured thick cut

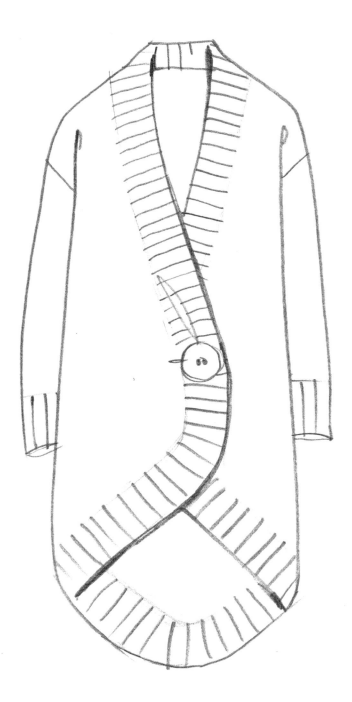

Asymmetric coat

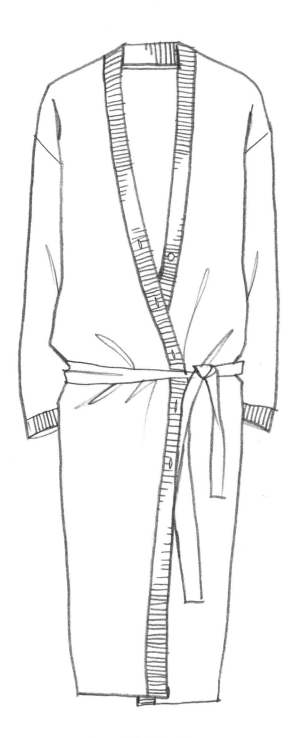

Long and tied at the hip

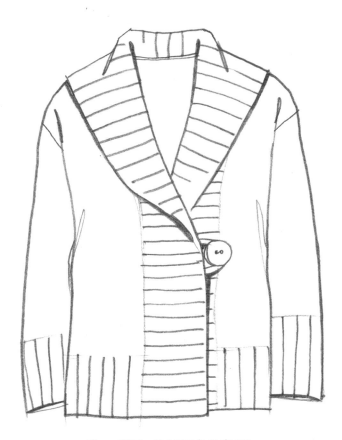

Big and thick with button-loop closure

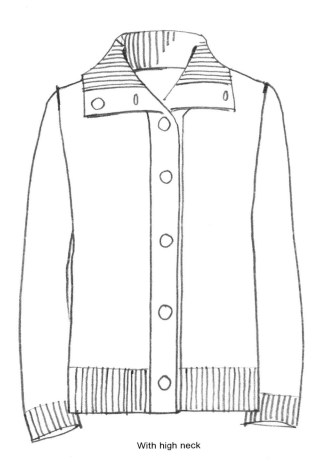

With high neck

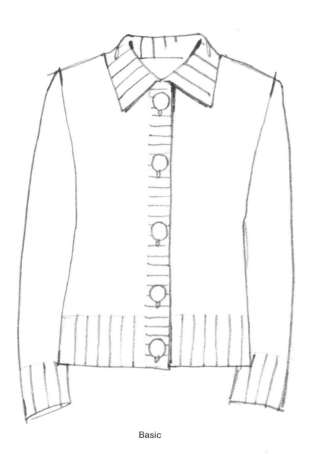

Basic

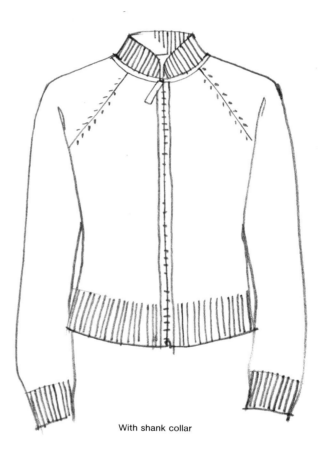

With shank collar

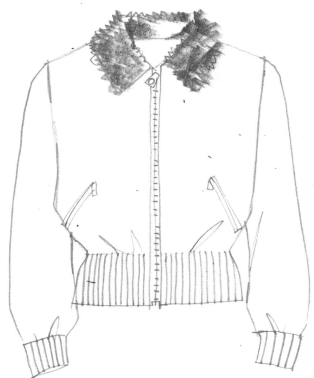

With fur collar

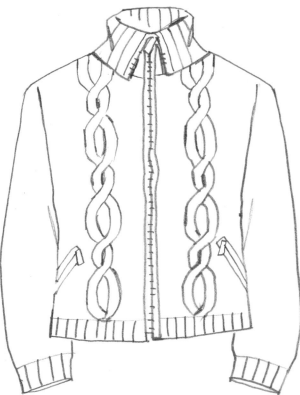

With turtleneck and braids

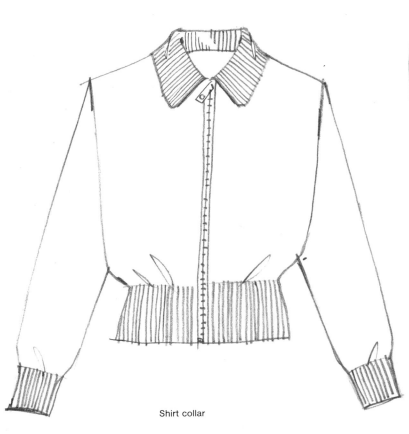

Shirt collar

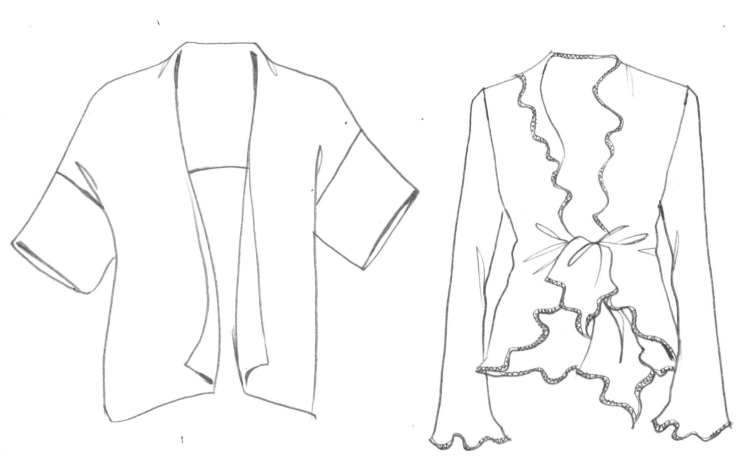

Shawl/Bolero

Very light, knotted and with overlock finishings

Skirts
Dresses
& Pants

Skirts

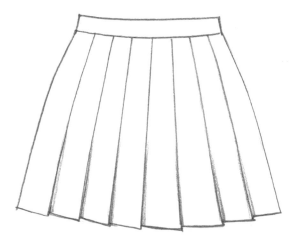

Pleated skirt

Scottish kilt

Split skirt

A-line skirt

Tulip skirt

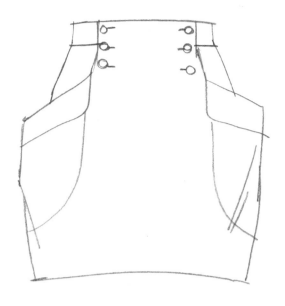

Sack skirt

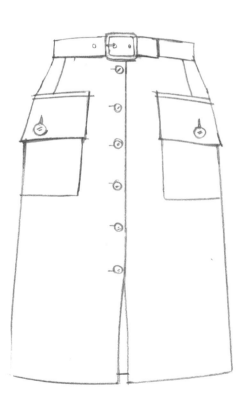

Military-style skirt

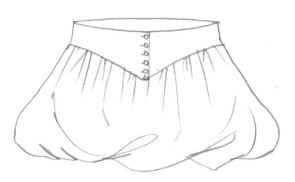

Poof skirt

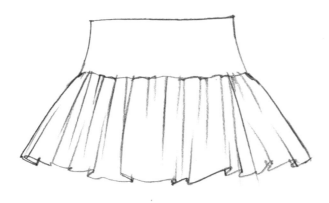

Ballerina skirt

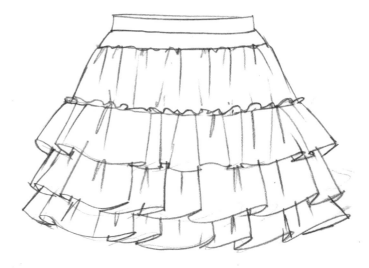

Ruffle skirt

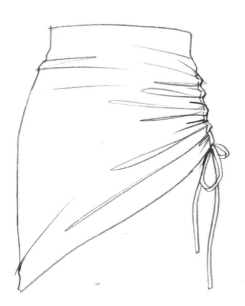

Straight skirt with side tuck

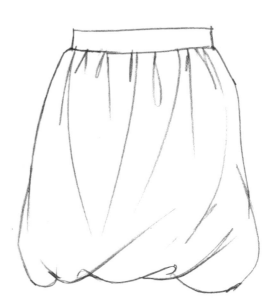

Balloon skirt

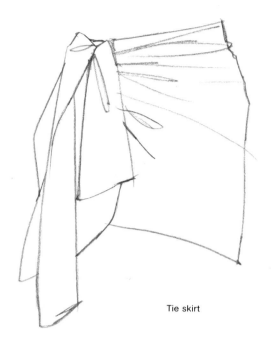

Tie skirt

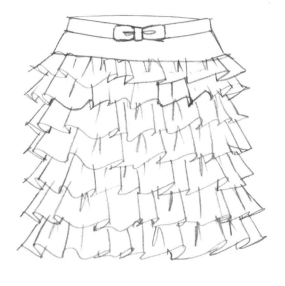

Cocktail skirt with ruffles and netting

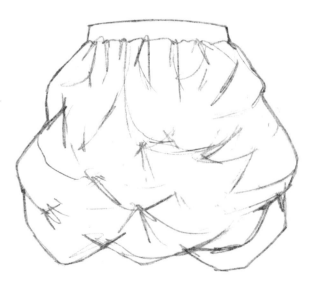

"Boulonne" skirt

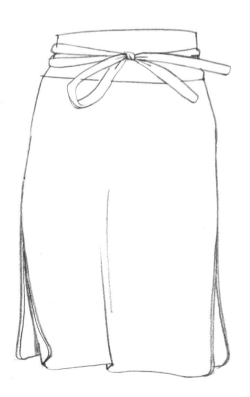

Skirt with side slits

57

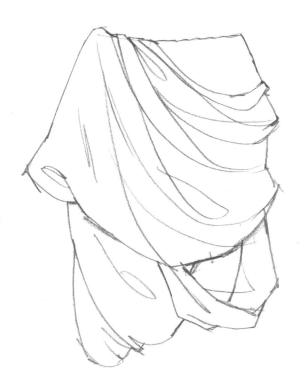

"Godess" or toga skirt

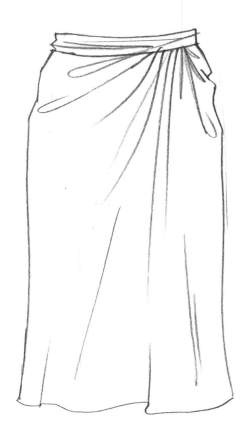

Draped skirt

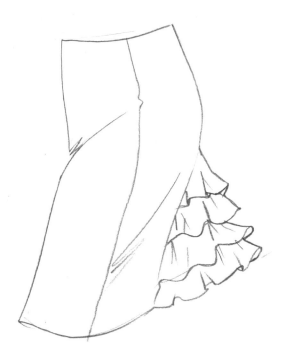

Profile view of skirt with ruffles on back

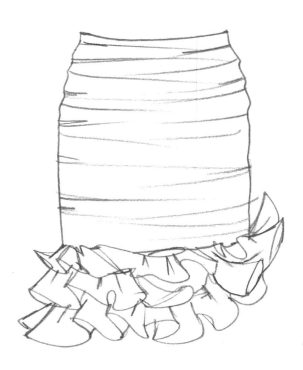

Creased cocktail skirt

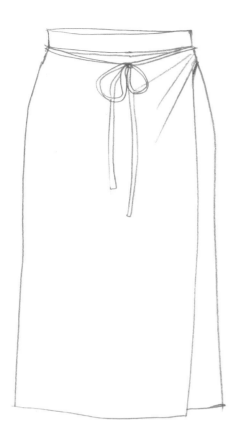

Apron skirt

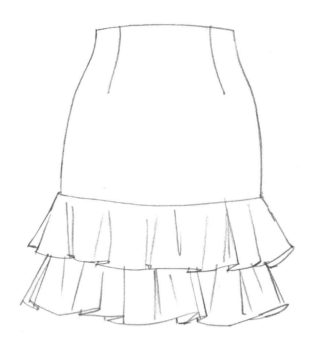

Skirt with ruffles on the bias

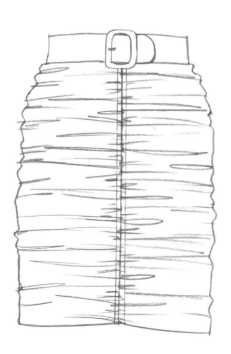

Creased skirt

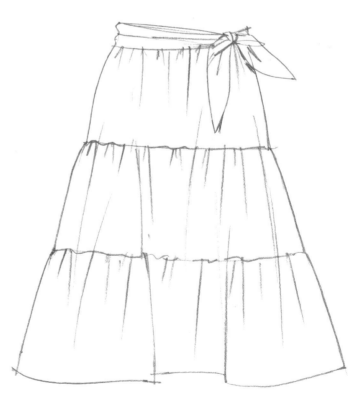

"Peasant" skirt

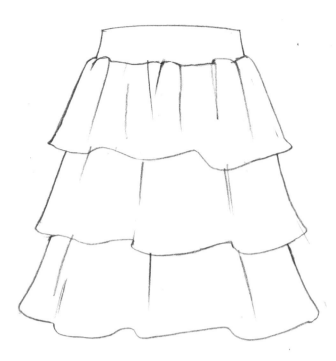

Skirt with satin ruffles

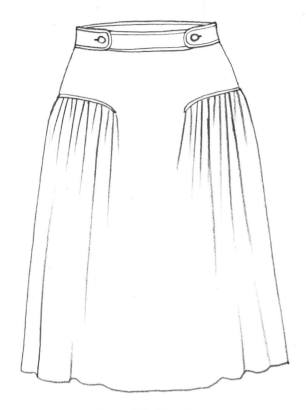

Corolla skirt with welt seams

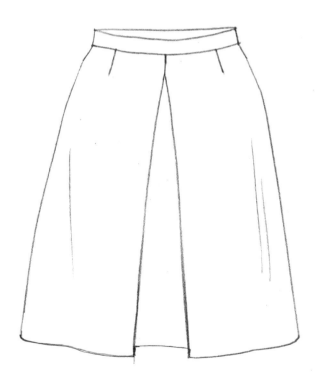

Skirt with gathering

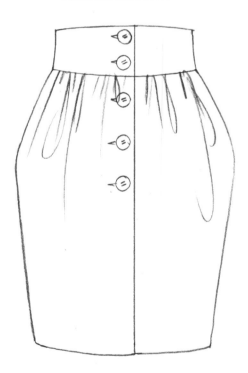

Tulip skirt

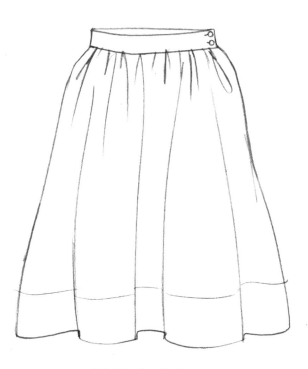

Full skirt with gathering

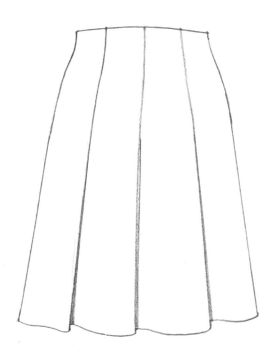

Skirt with sewn pleats from the hip down

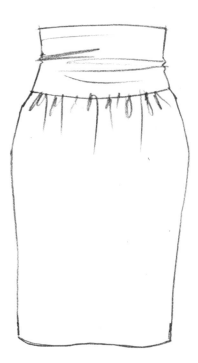

Straight skirt

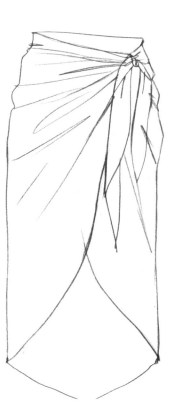

Sarong

61

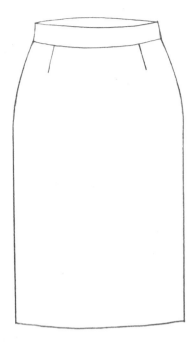

Straight skirt

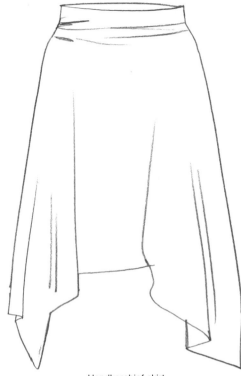

Handkerchief skirt

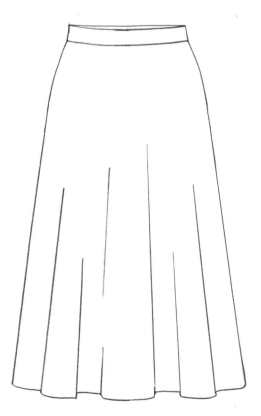

Layered skirt

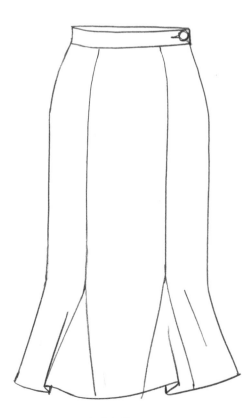

Godet skirt

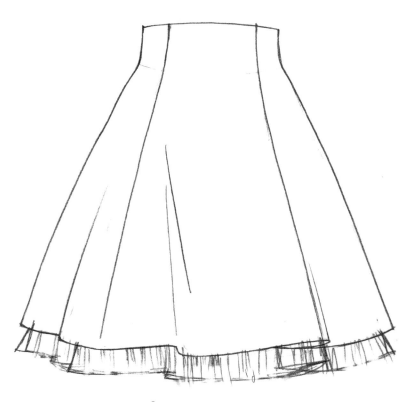

Can-can skirt with tutu

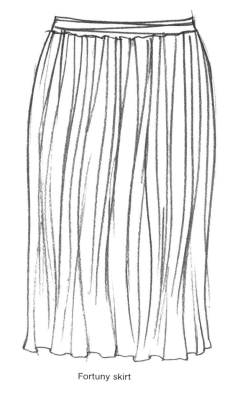

Fortuny skirt

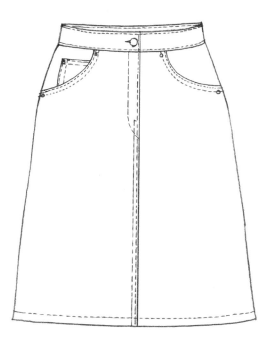

Denim skirt

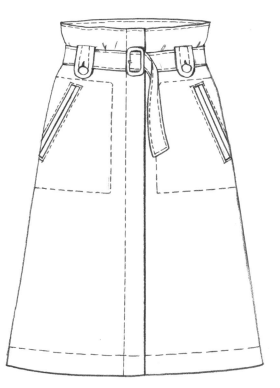

Safari-style skirt

Dresses

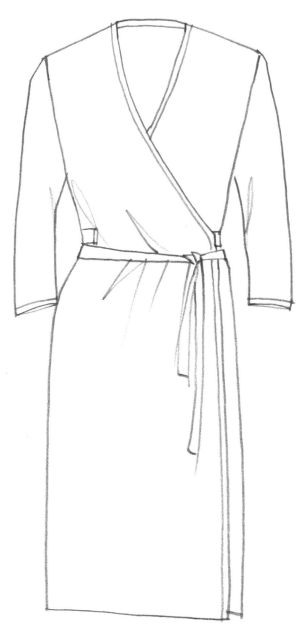

Wrap dress

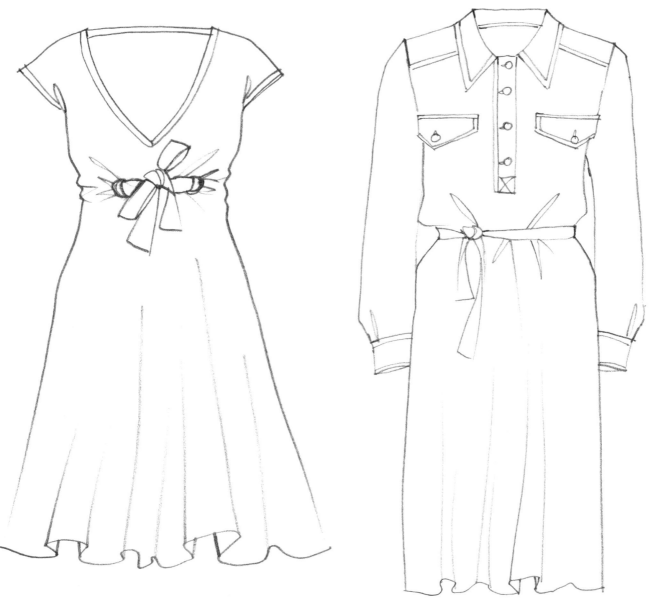

Empire lace

Polo-shirt dress

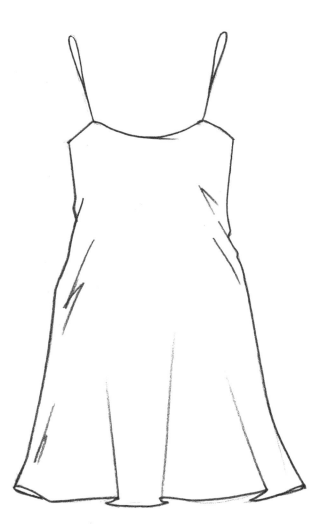

Beach dress

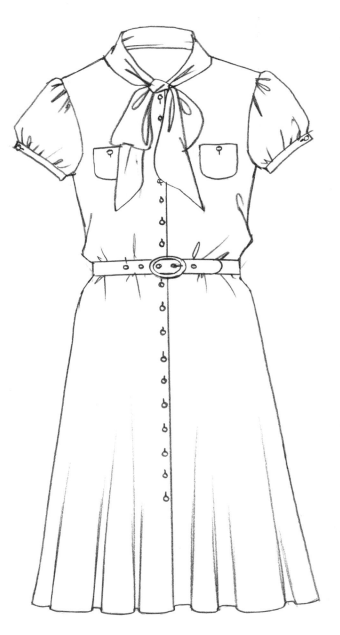

Retro-blouse dress

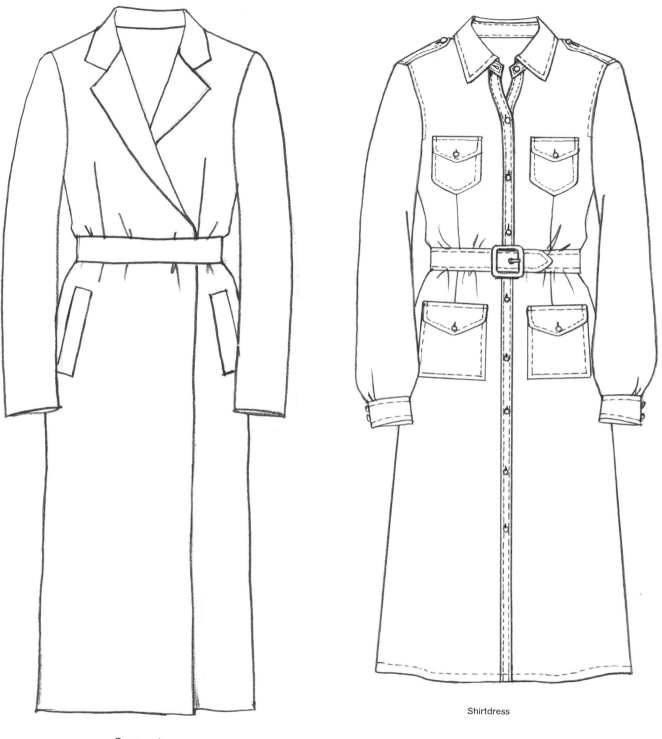

Dress coat

Shirtdress

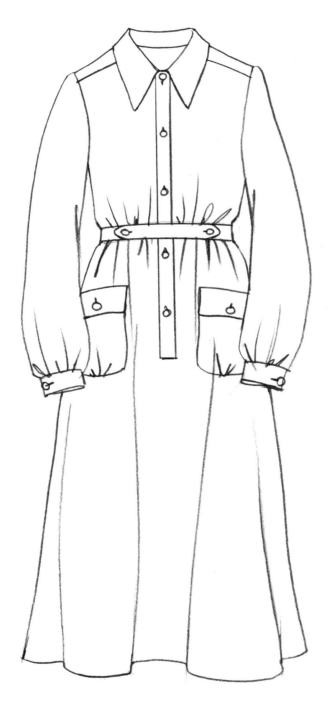

Uniform dress

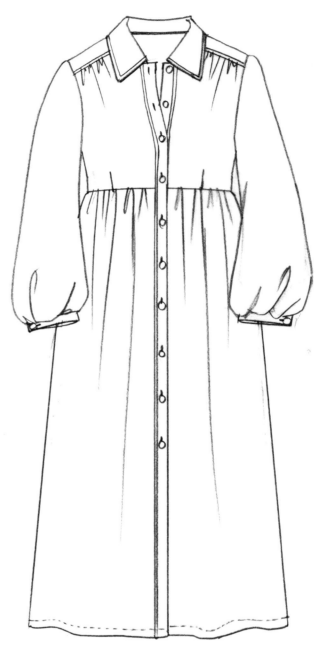

"Peasant" dress

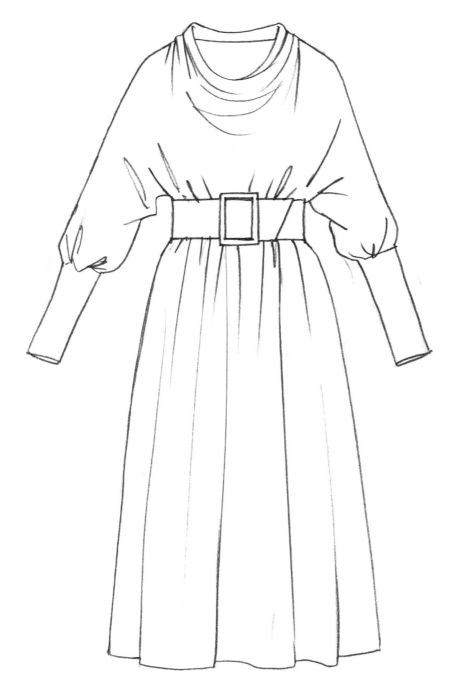

Dress with cowl neckline and 1930s batwing sleeves

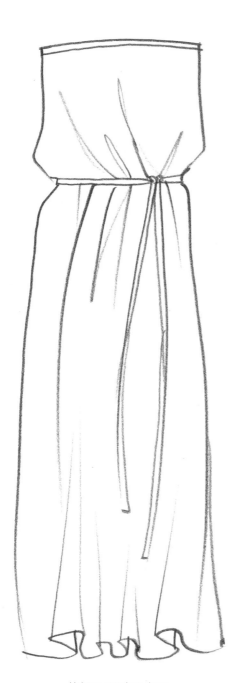

Halston strapless dress

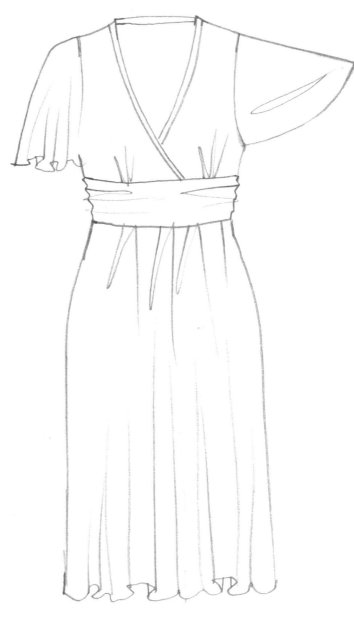

1970s retro dress

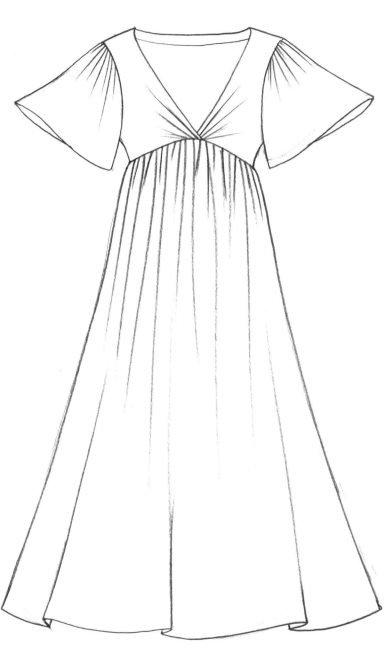

Butterfly dress

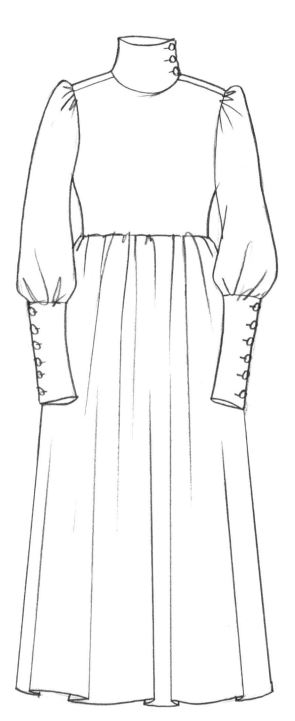

Biba dress

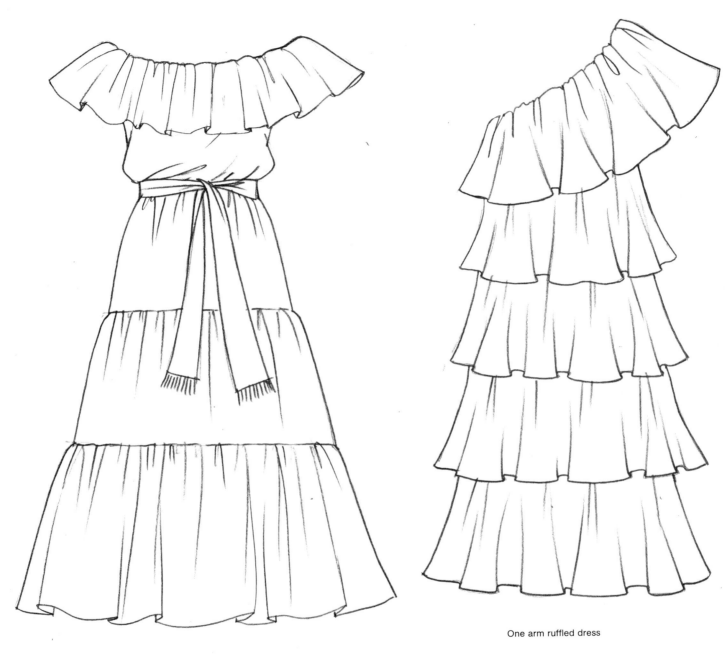

Folk dress

One arm ruffled dress

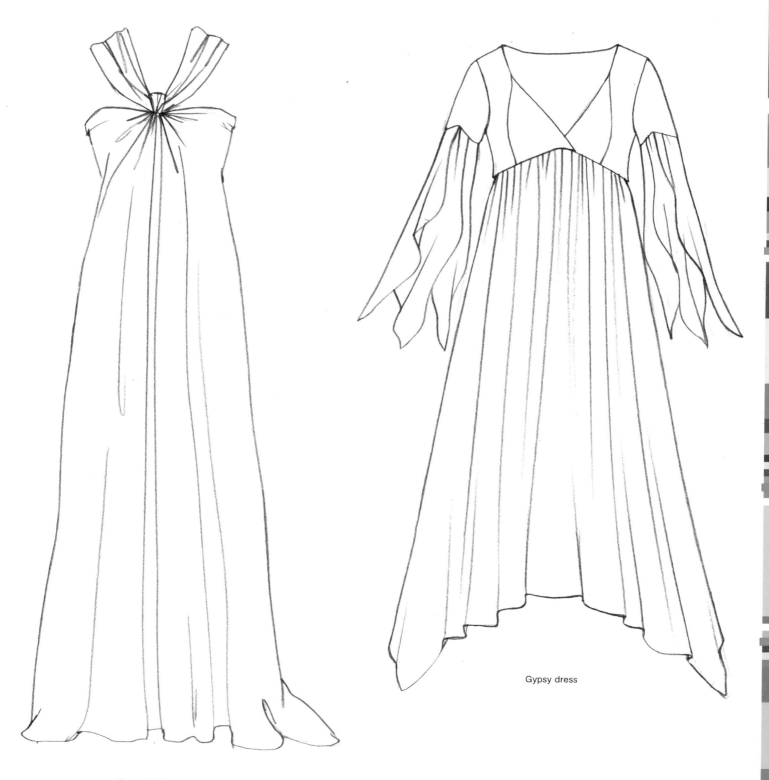

Draped nightdress

Gypsy dress

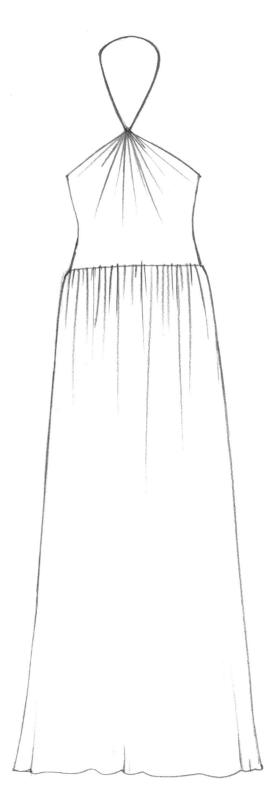

Fine halter-neck dress

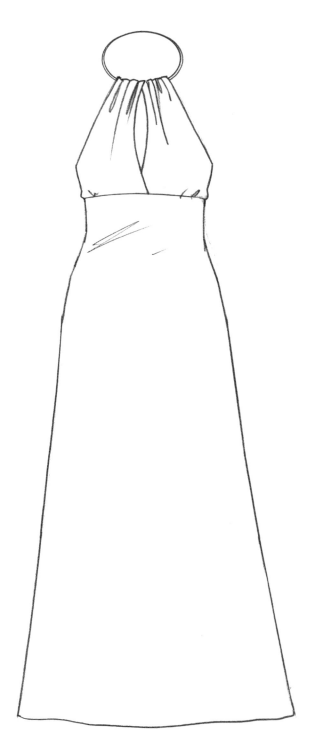

Halter neck with metal hoop

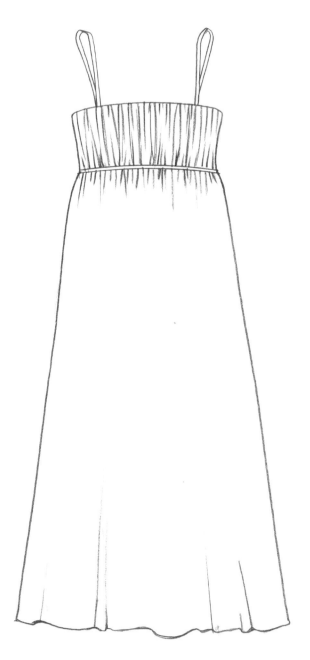

Empire dress

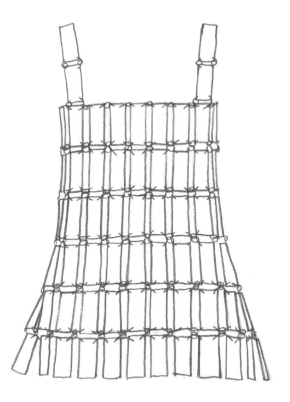

Chainmail dress

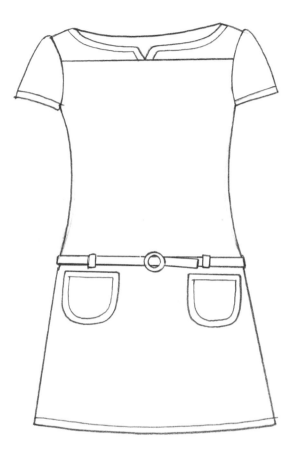

A-line dress

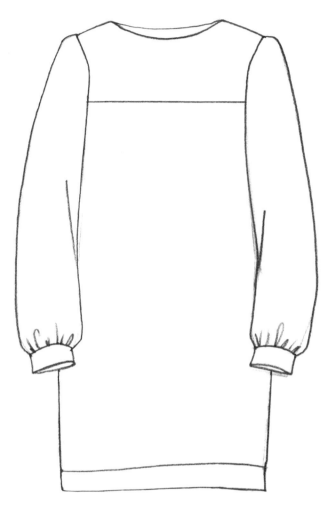

Sack dress

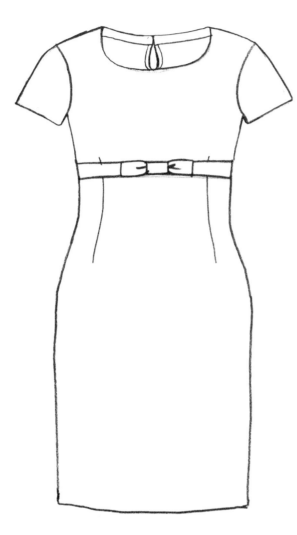

Cocktail dress

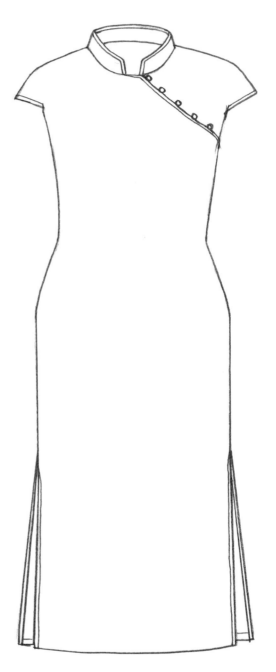

Chinese dress

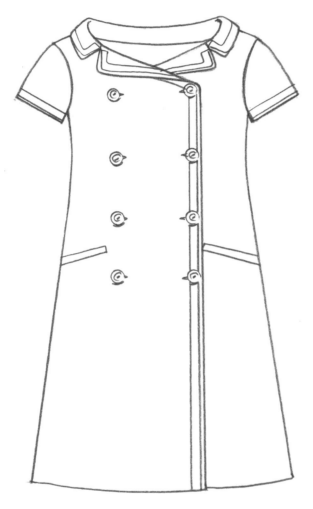

1960s dress coat

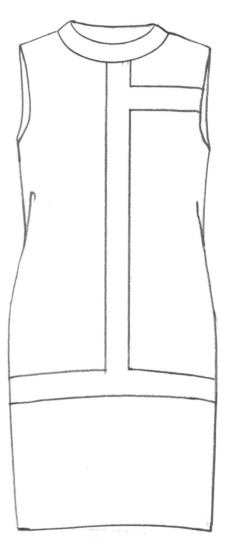

Straight dress with 1960s geometric print

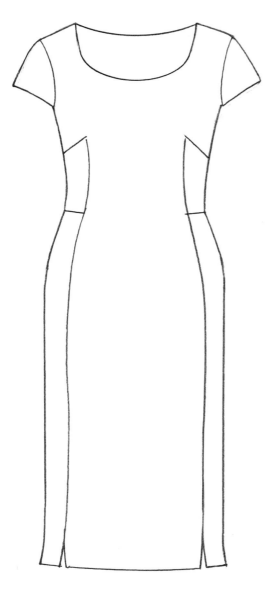

Little black dress

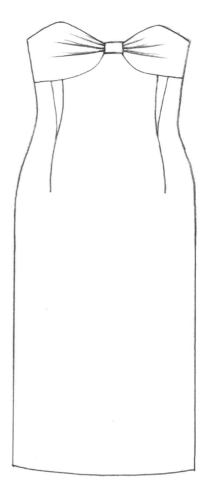

1950s bathing dress

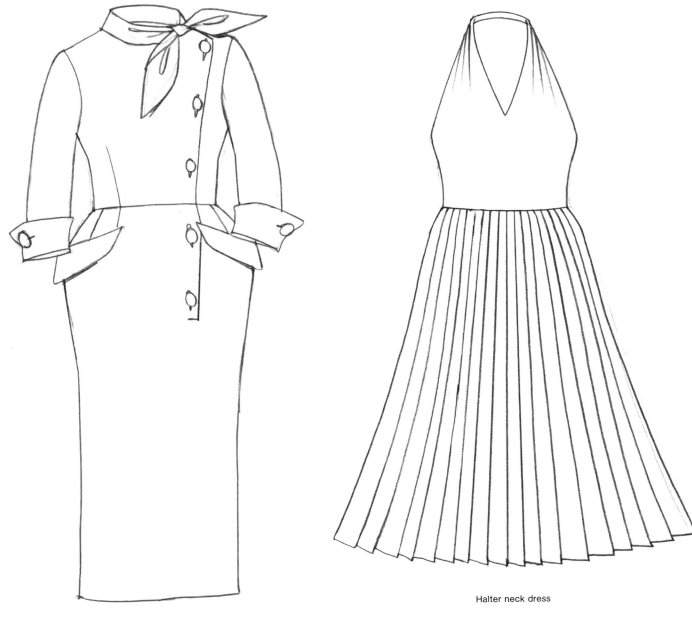

1950s retro dress

Halter neck dress

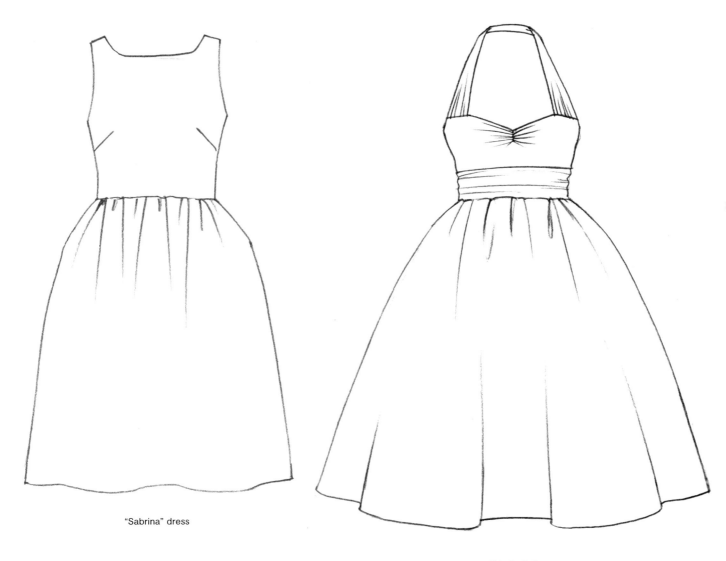

"Sabrina" dress

"Marilyn" dress

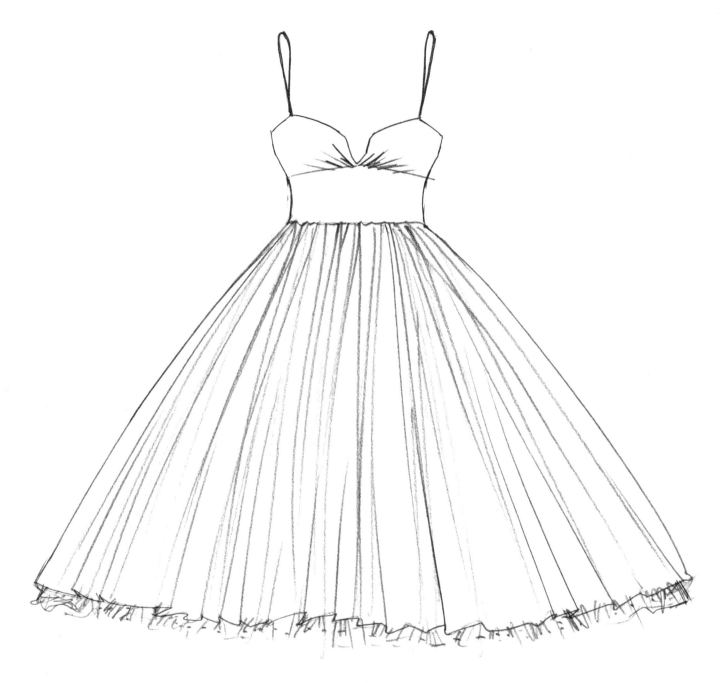

Princess-line dress

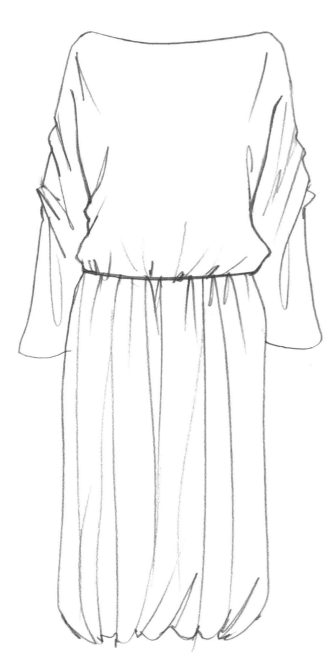

Retro dress from beginning of twentieth century

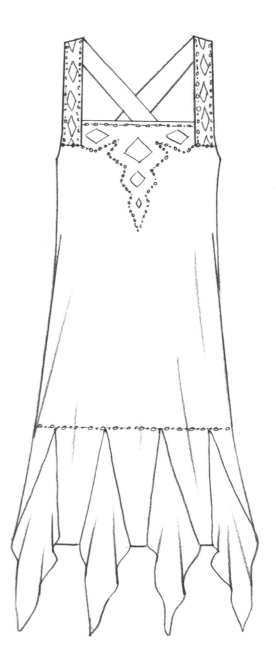

Charleston dress

Pants

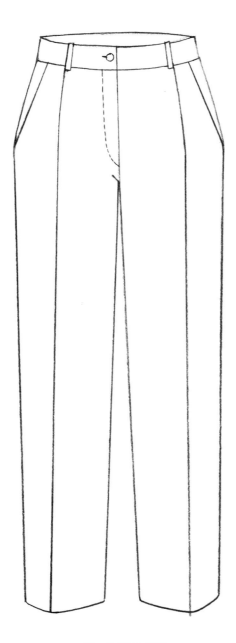

Classic pants, *front*

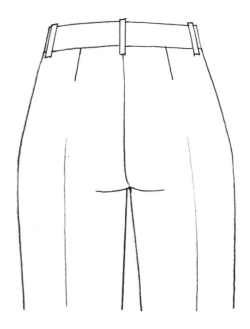

Classic pants, *back*

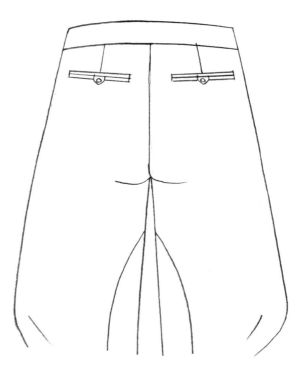

Jodhpur pants, *back*

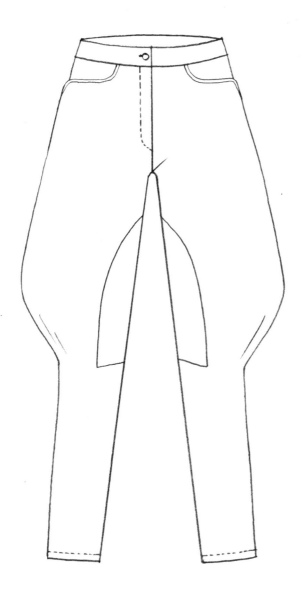

Jodhpur pants, *front*

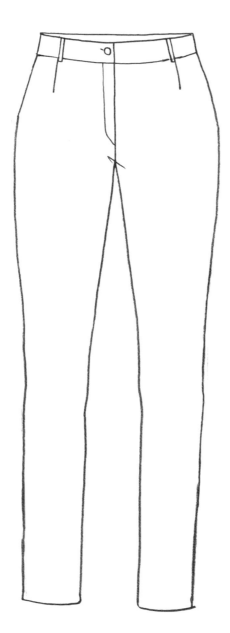

Fitted pants

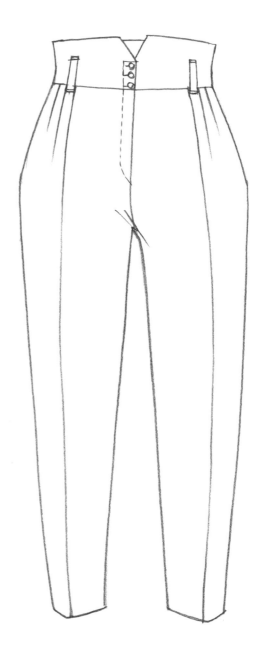

Bombacho pants

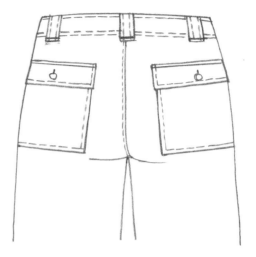

Cargo pants, *back*

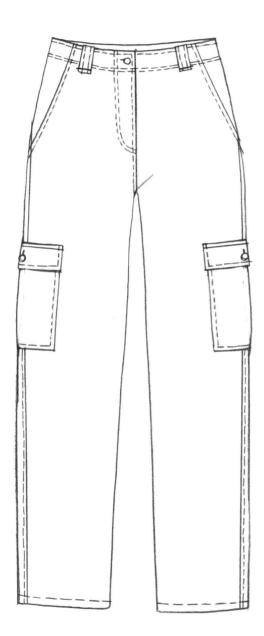

Cargo pants, *front*

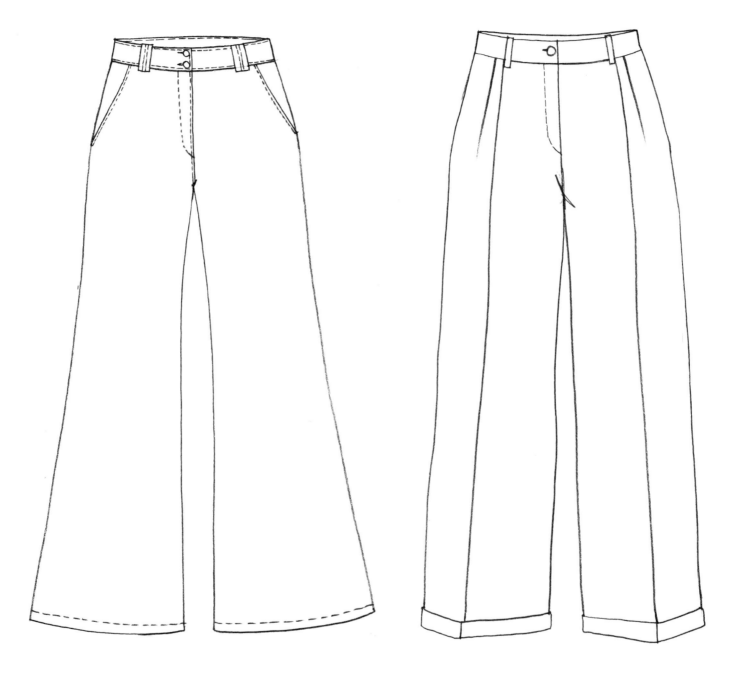

Bell-bottom pants

Baggy pants

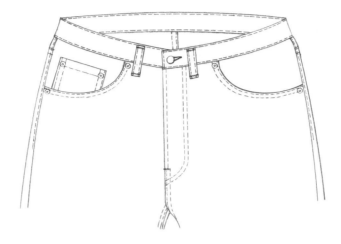

Detail high pants, *front*

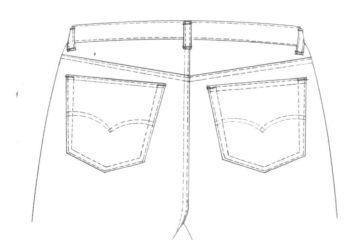

Detail high pants, *back*

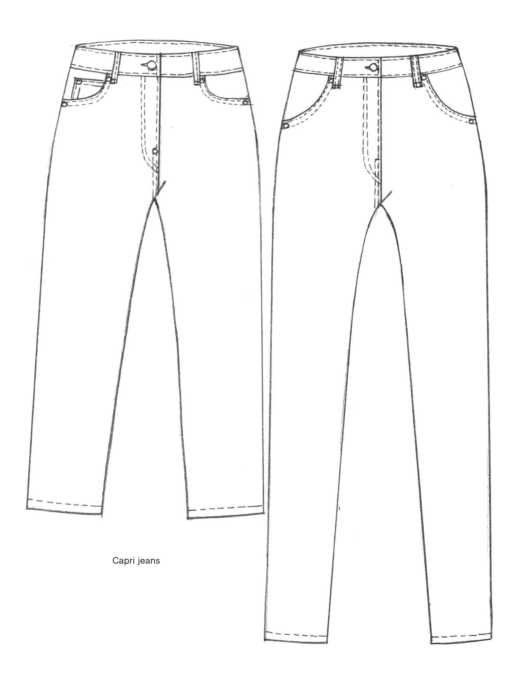

Capri jeans

Tight jeans

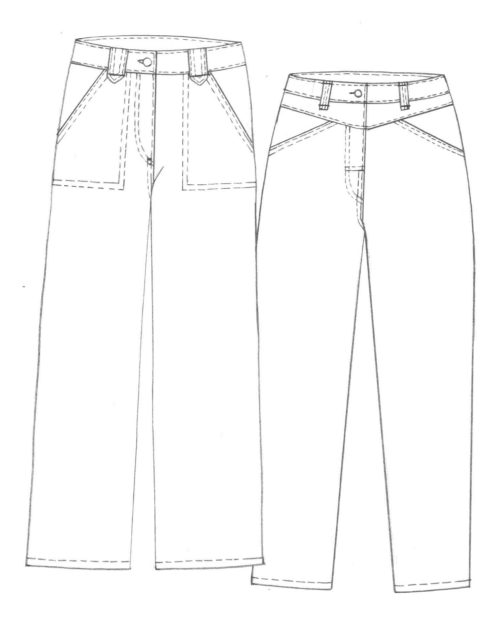

Wide jeans Baggy jeans

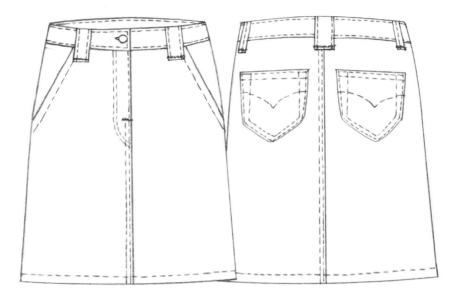

Denim skirt

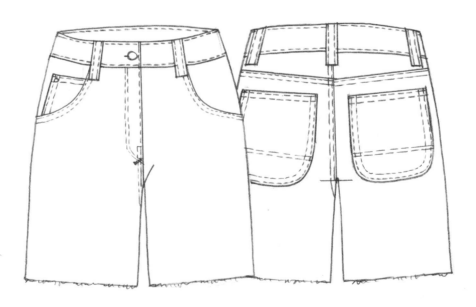

Denim Bermudas

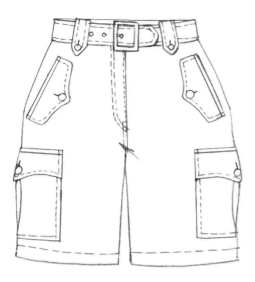

Safari shorts

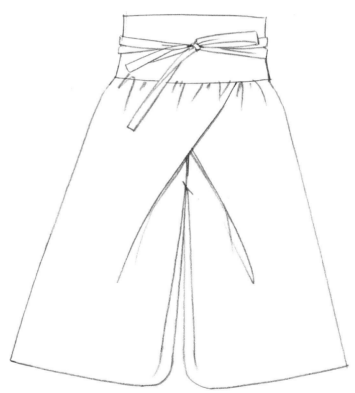

Samurai pants

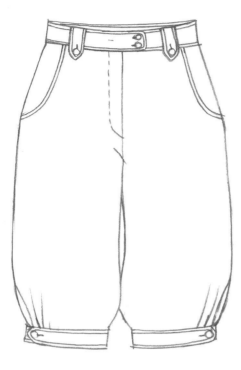

Knickers

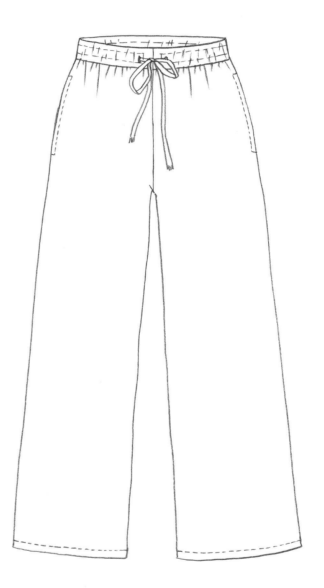

Pajama pants

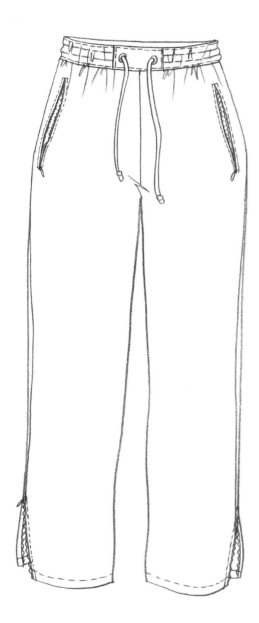

Sweatpants

Retro shorts

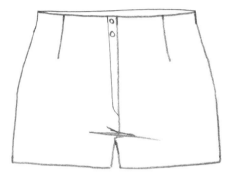

1960s shorts

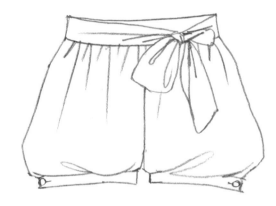

Poof shorts with tie

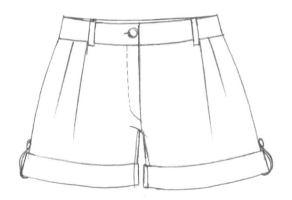

Shorts

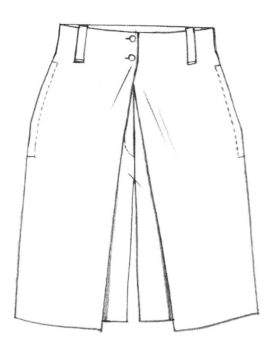

Apron pants

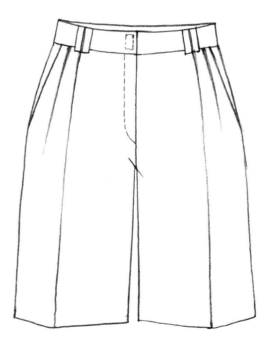

Bermudas

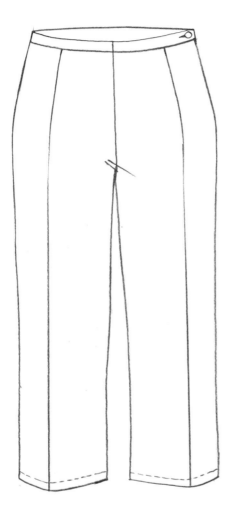

Cropped pants

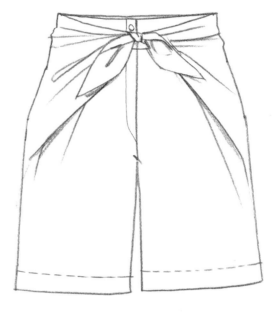

Sarong pants

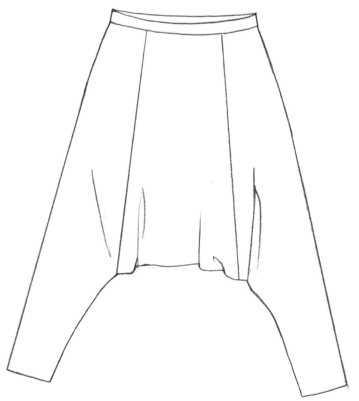

Saruel pants

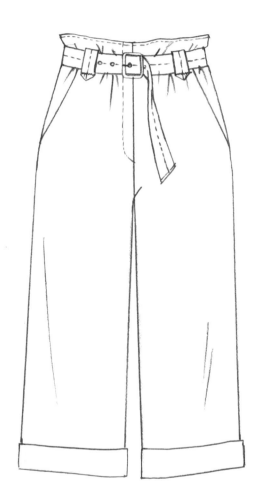

Capri pants

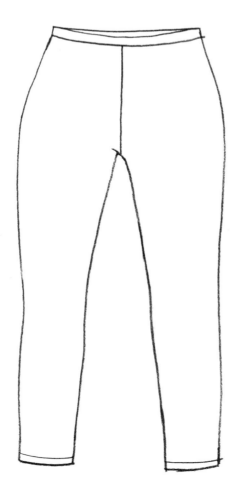

Leggings

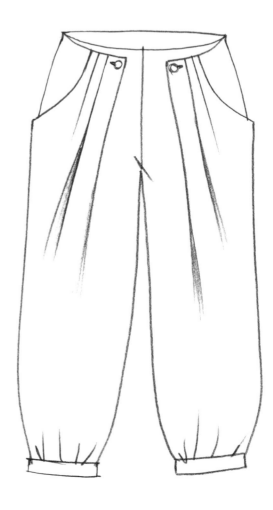

Bombacho pants

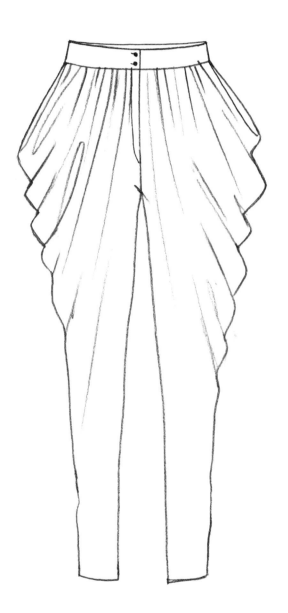

1980s pants

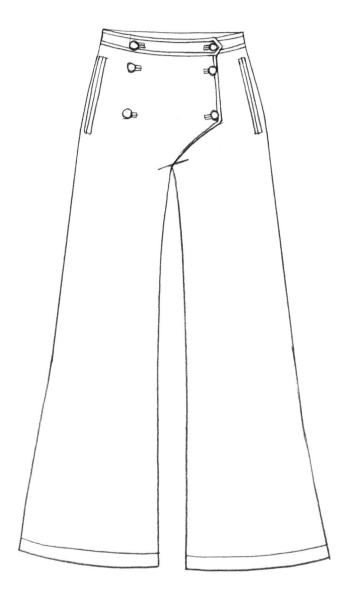

Marine-style pants

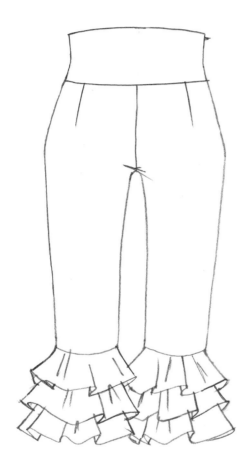

Carioca pants

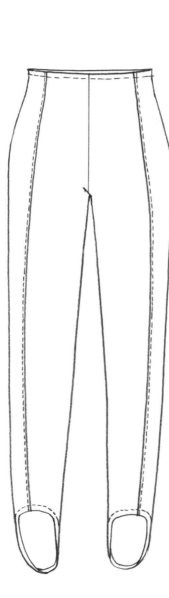

Fuseau ski pants

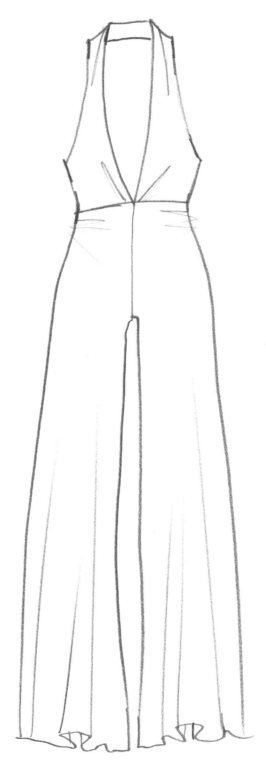

Halston jumpsuit

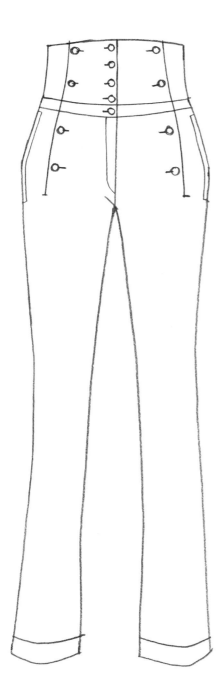

Cadet pants

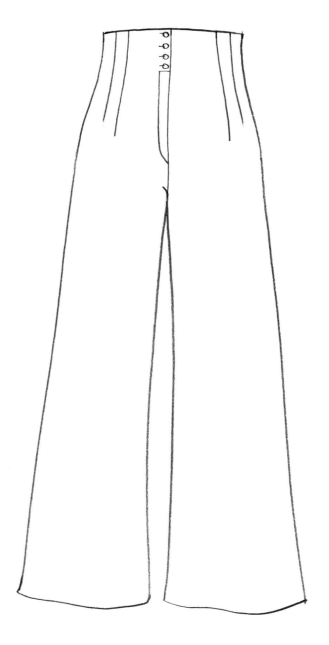

1960s retro pants

Jackets & Coats

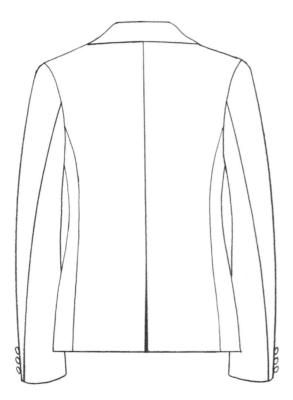

Tailored jacket, *back*

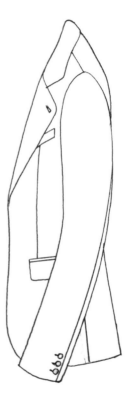

Tailored jacket, *profile*

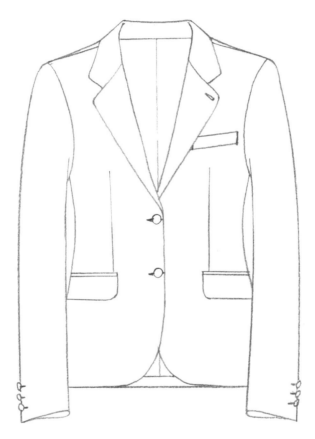

Tailored jacket, *front*

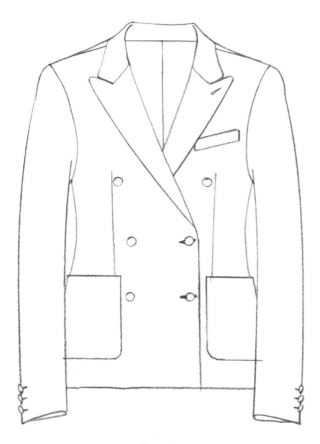

Blazer, *front*

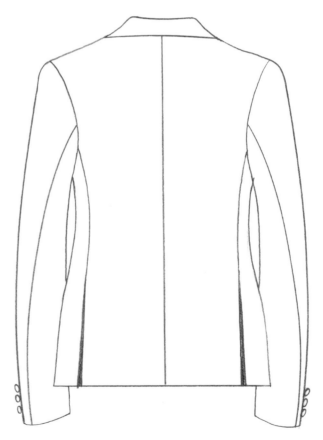

Blazer, *back*

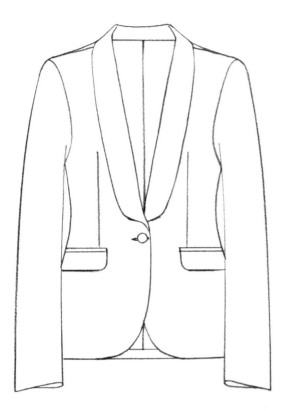

Dinner jacket

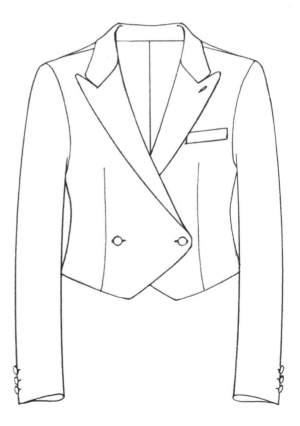

Spencer jacket

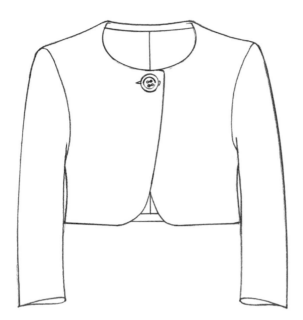

Bolero jacket

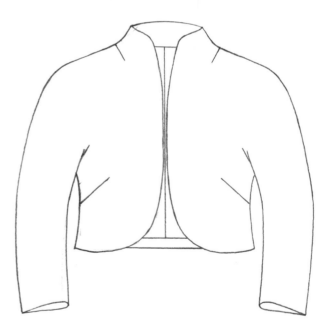

Bolero jacket with Japanese sleeve

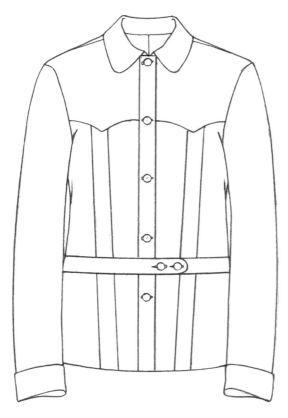

Hunting jacket

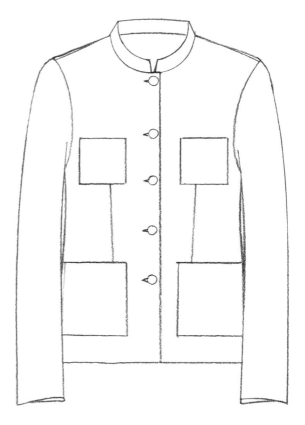

Mao-style jacket

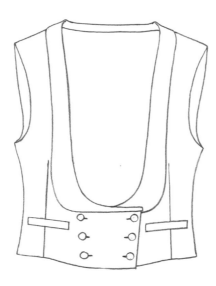

Waistcoat for tailcoat

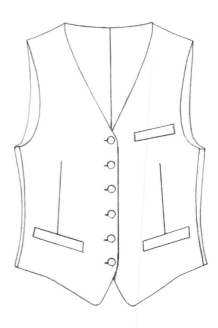

Waistcoat, *front*

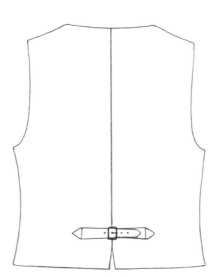

Waistcoat, *back*

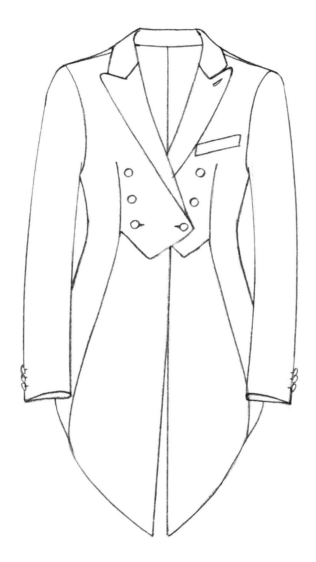

Tailcoat

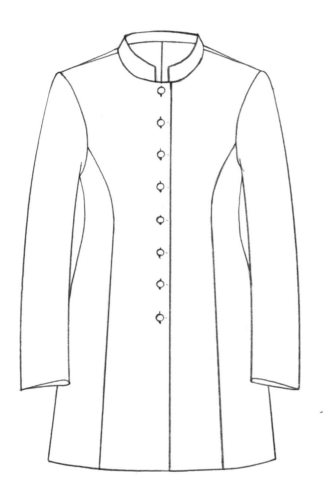

Frock coat with Mao-style collar

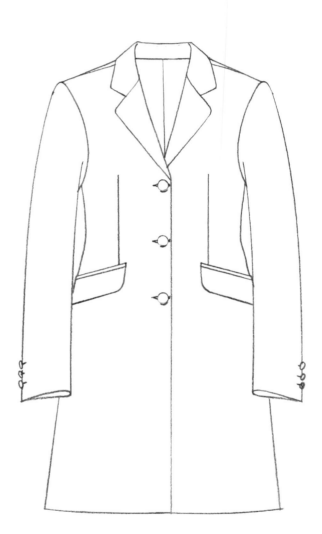

Frock coat

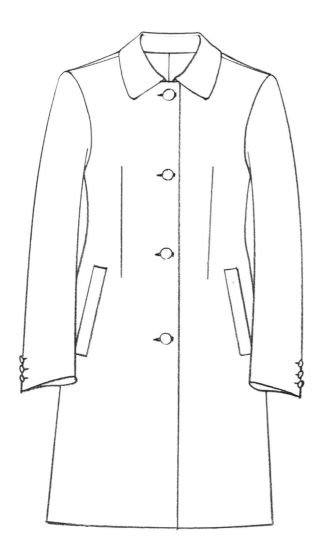

Smart coat

Marine-style coat

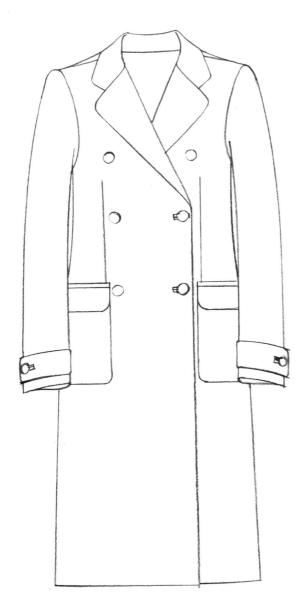

Classic coat, *front*

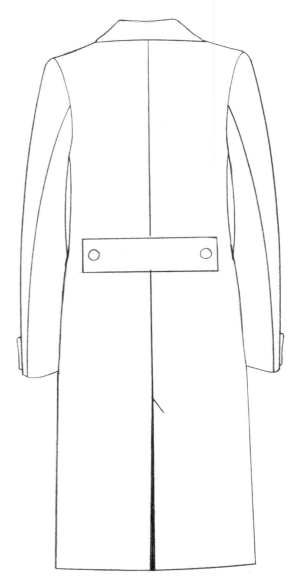

Classic coat, *back*

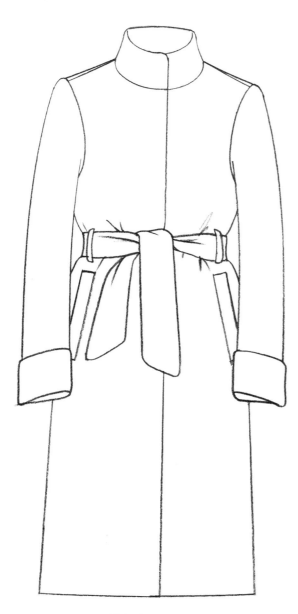

Minimalist coat, *front*

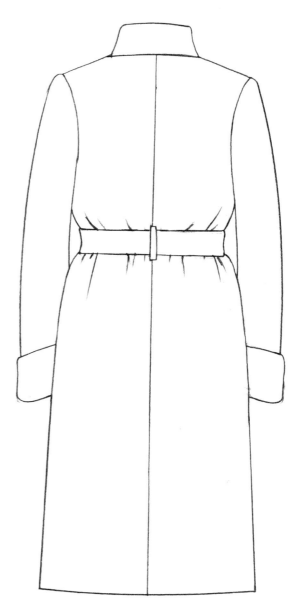

Minimalist coat, *back*

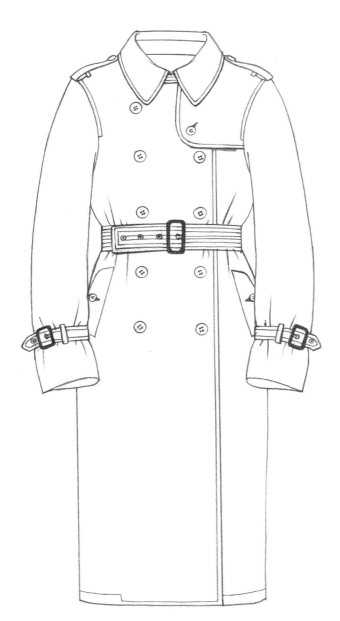

Trench coat, *front*

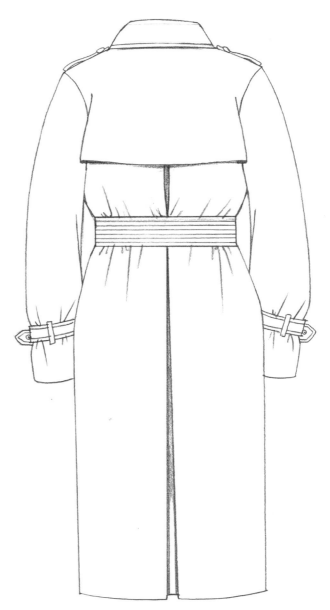

Trench coat, *back*

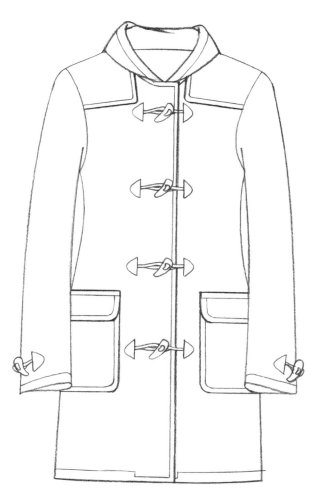

Montgomery jacket, *front*

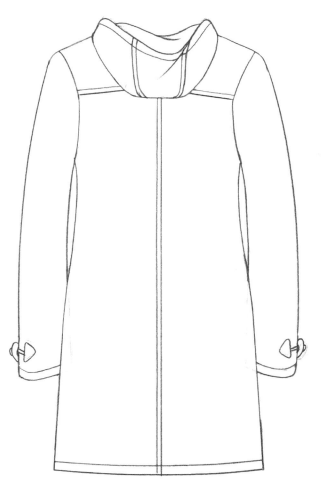

Montgomery jacket, *back*

A-line coat

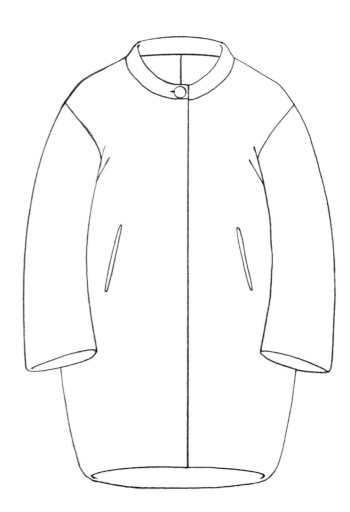

Balloon coat

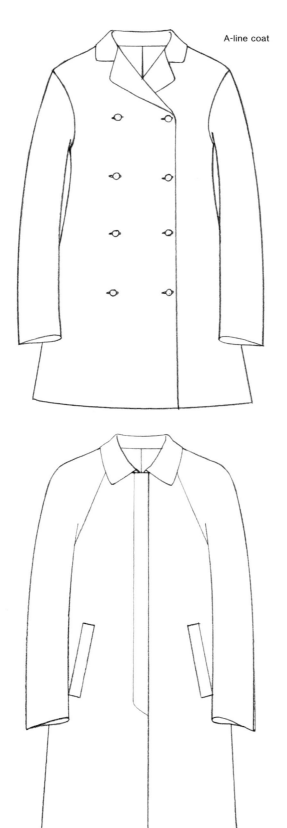

Raincoat

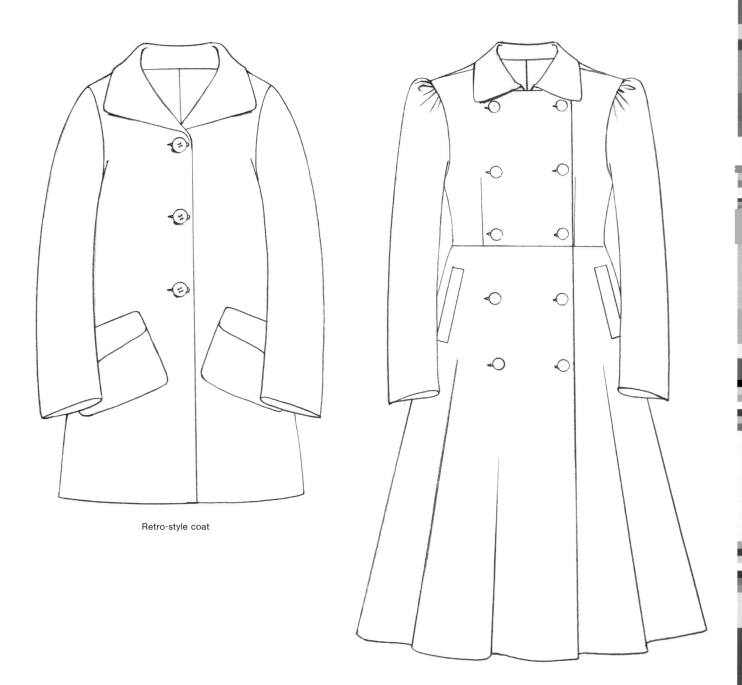

Retro-style coat

Flared coat

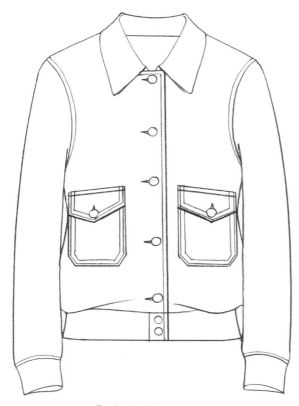

Bomber jacket

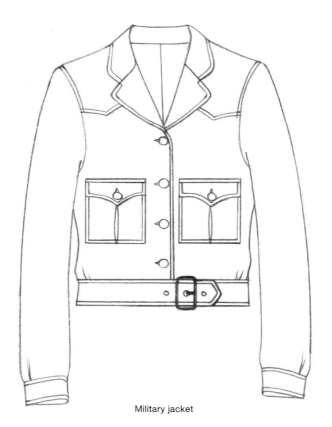

Military jacket

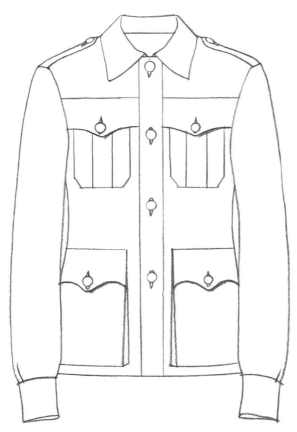

Safari jacket, *front*

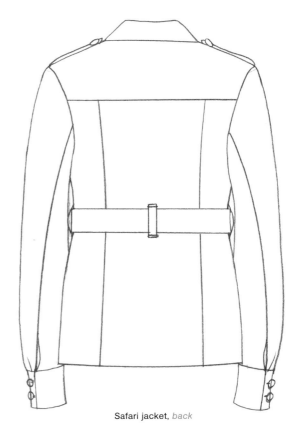

Safari jacket, *back*

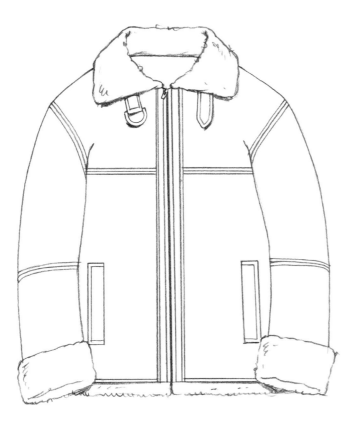

Leather bomber jacket

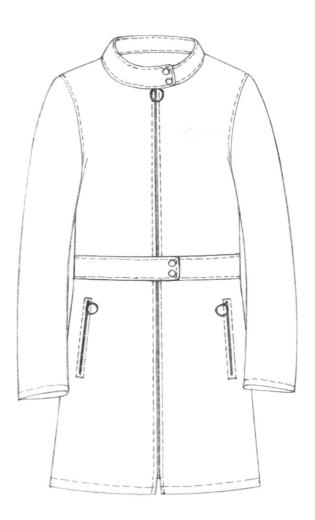

Patent leather 1960s coat

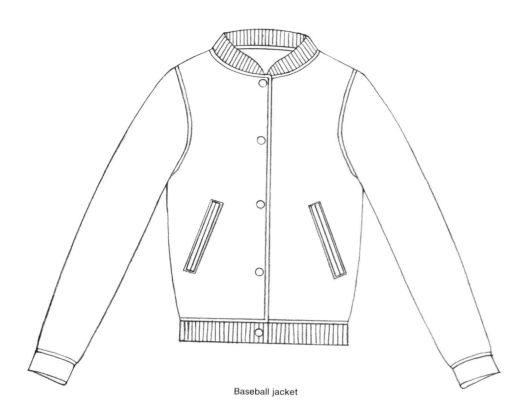

Baseball jacket

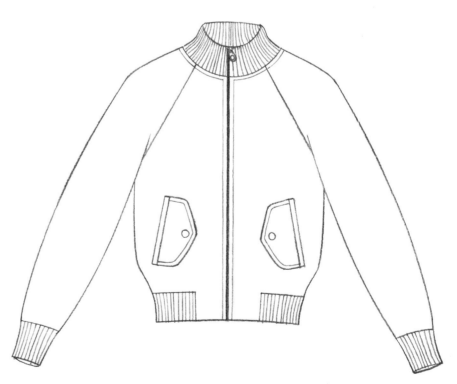

Bomber jacket

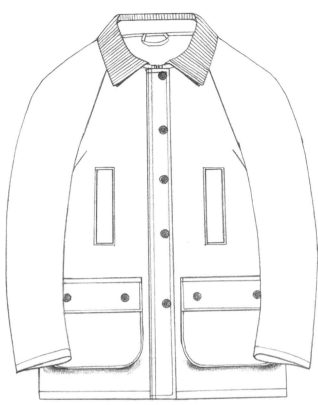

Barbour jacket

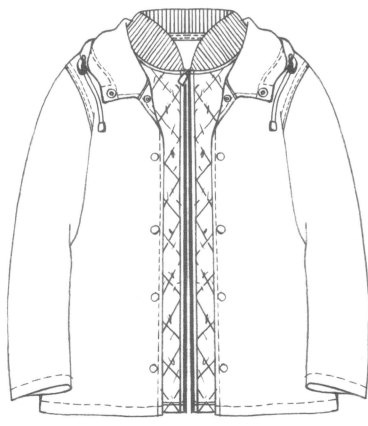

Double parka

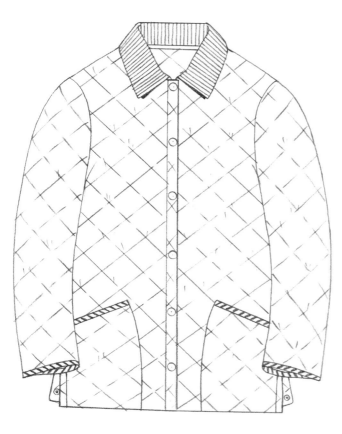

Barbour quilted jacket

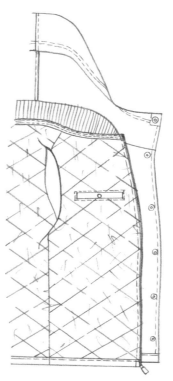

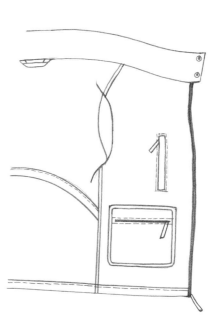

Parka insides

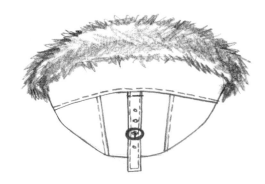

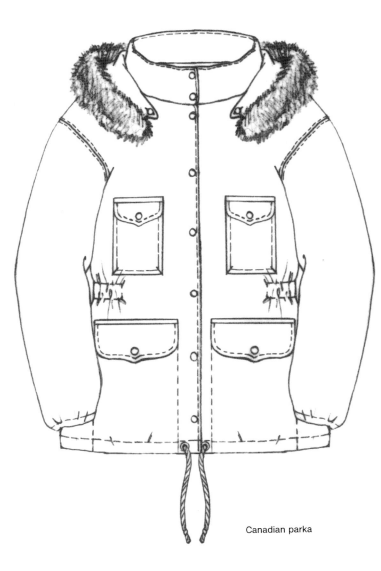

Canadian parka

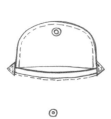

Parka details: hood, collar and pocket

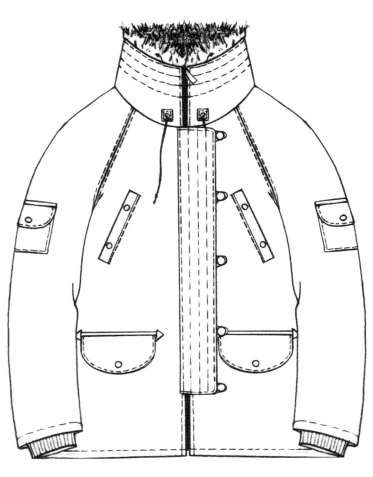

Fur-lined parka

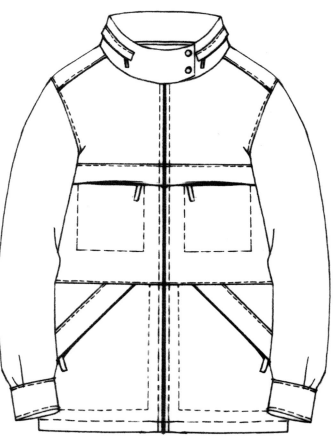

Training parka

Anorak

Fitted anorak

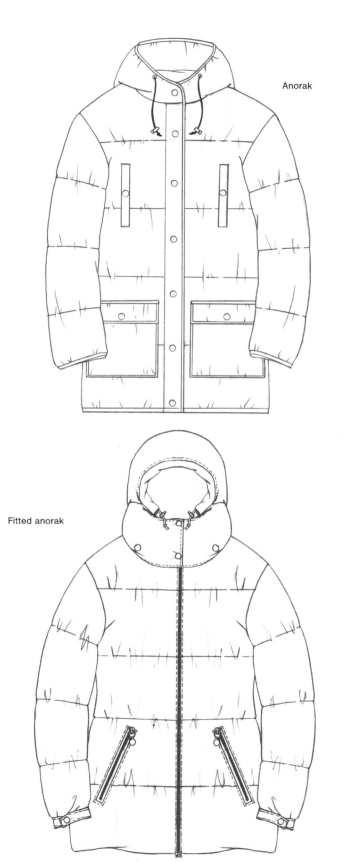

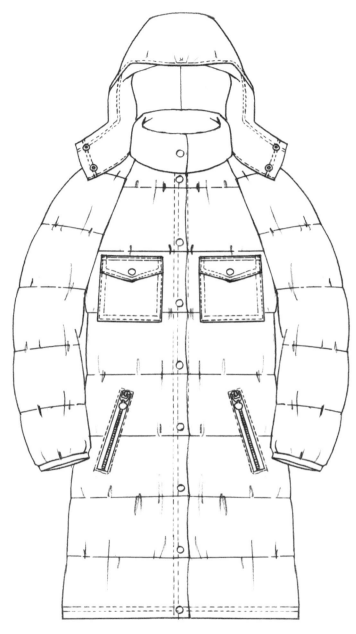

Long anorak / ski jacket

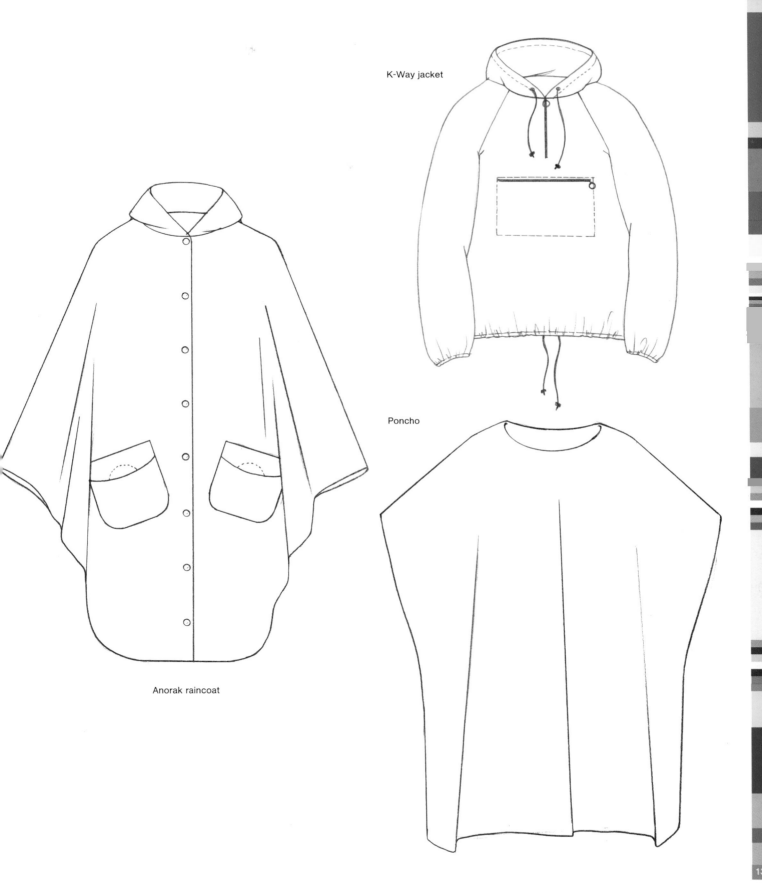

K-Way jacket

Poncho

Anorak raincoat

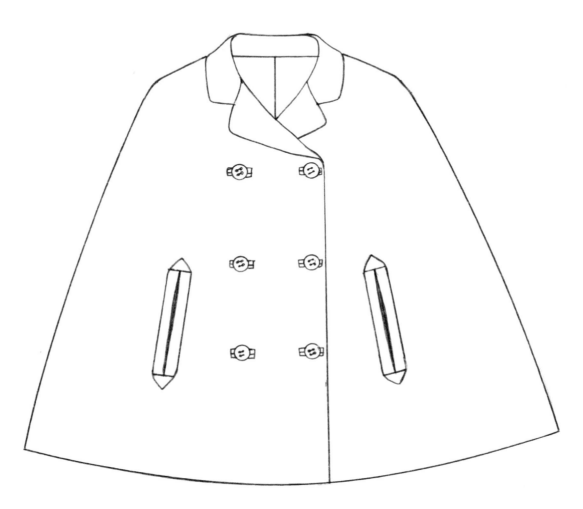

Double-breasted cape

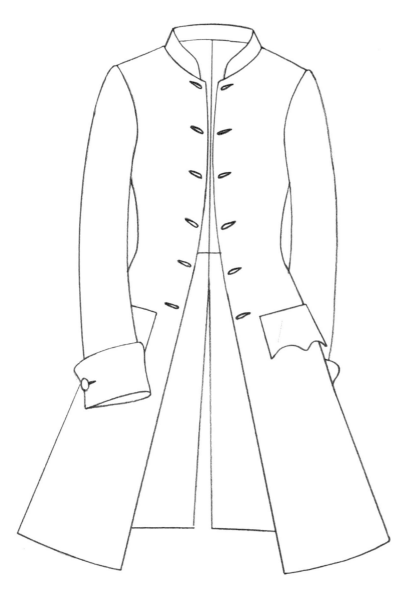

Frock coat, *front*

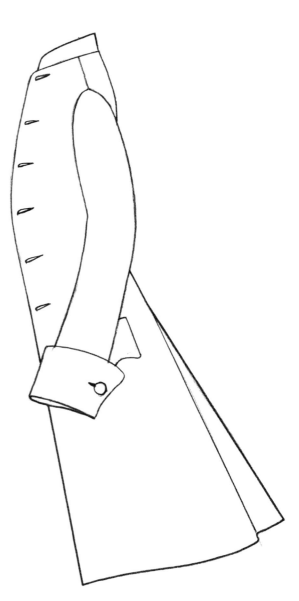

Frock coat, *profile*

Lingerie
Shoes
& Accessories

Lingerie

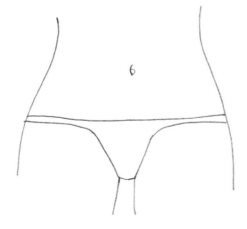

Thong

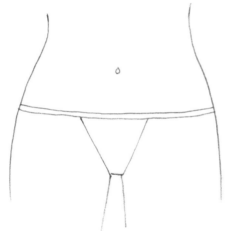

G-string

Tanga

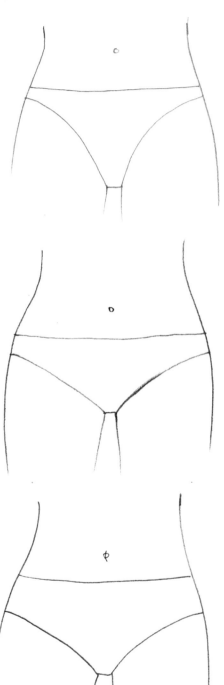

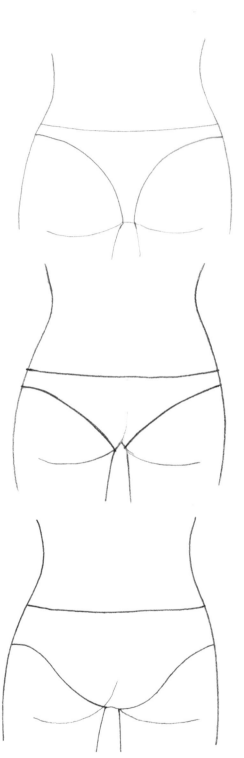

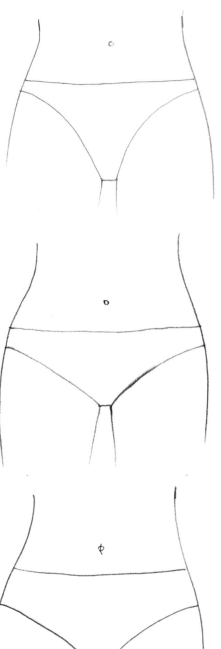

Bikini

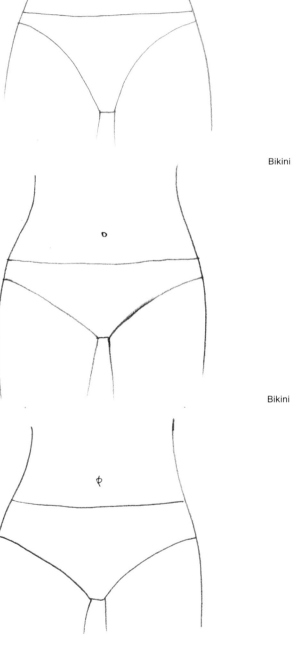

Bikini

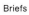

Briefs

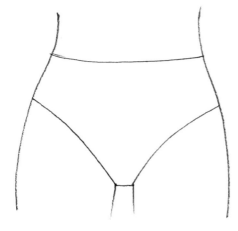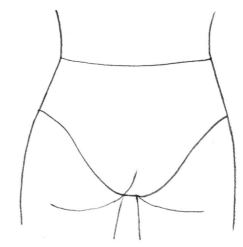

High-waist briefs

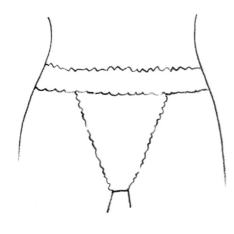

Lace panties

Boy shorts

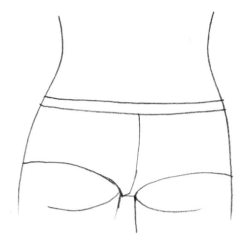

Tanga boy shorts

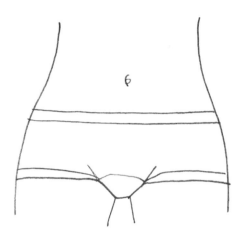
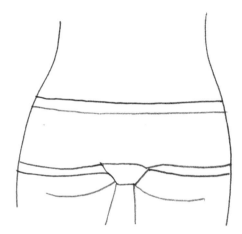

Tube boy shorts

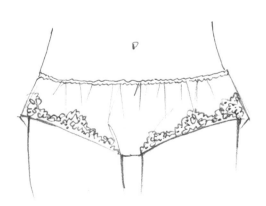
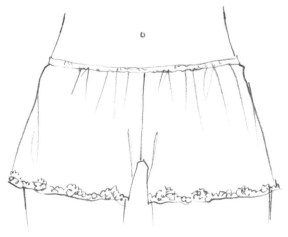

High and low French panties

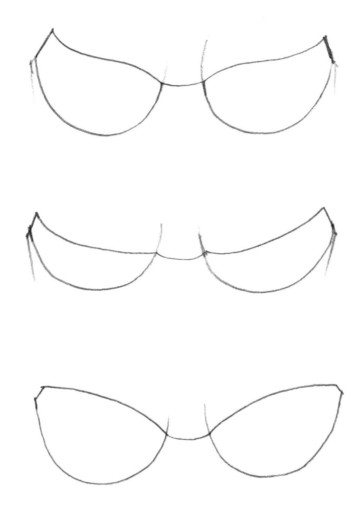

Décolleté: foam-filled or molded.

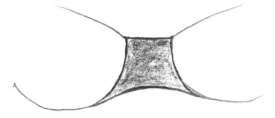

Full center gore

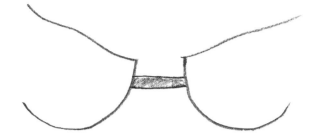

Single-banded center gore

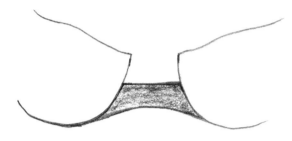

Half center gore

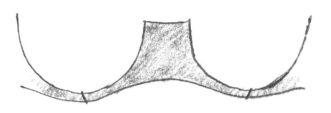

Center gore with inner sling

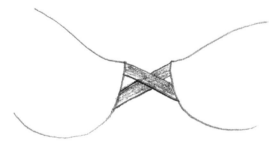

Crossed center gore

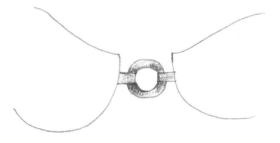

With washer

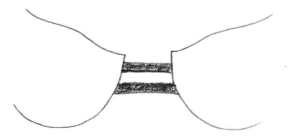

Double-banded center gore

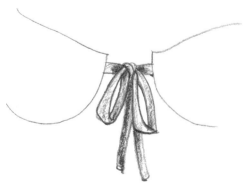

With bow

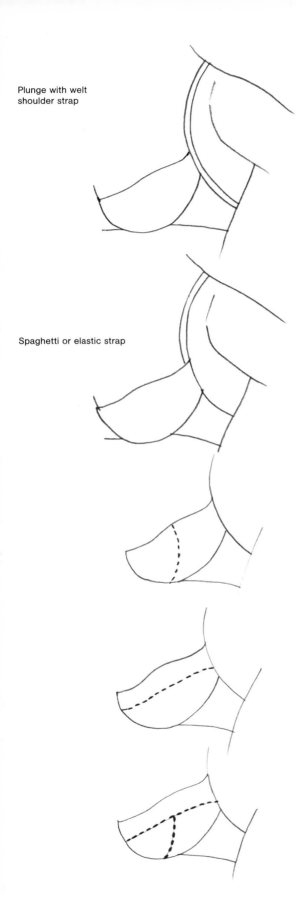

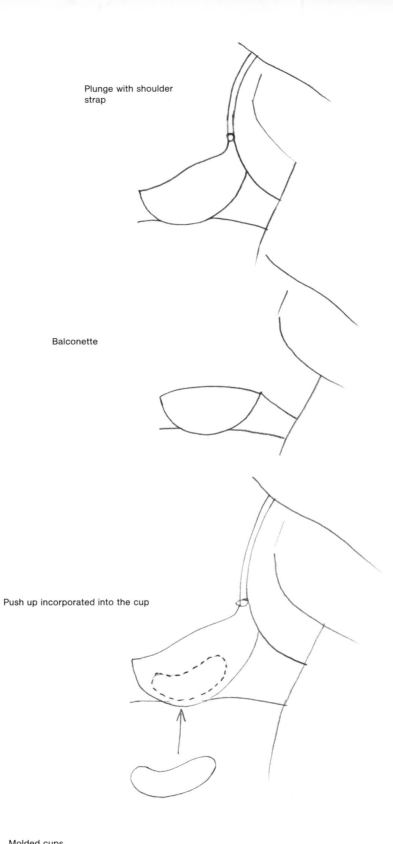

Plunge with welt
shoulder strap

Plunge with shoulder
strap

Spaghetti or elastic strap

Balconette

Push up incorporated into the cup

Molded cups

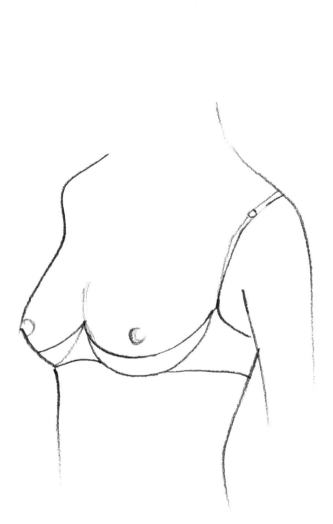

Center gore with inner sling

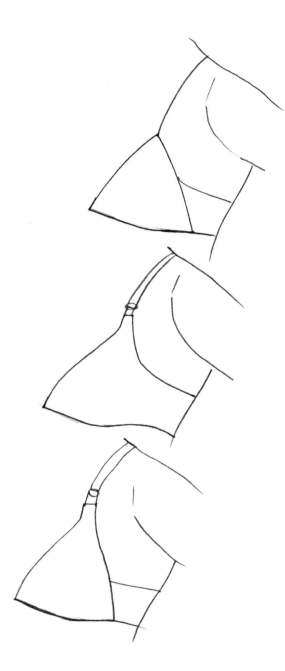

Triangular-shaped
cups

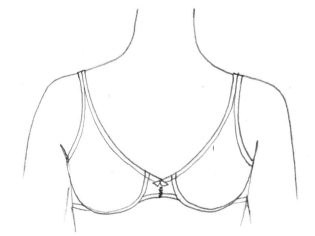
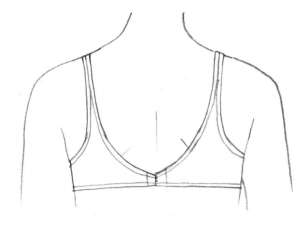

Bra with full center gore

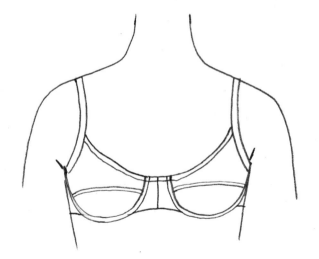
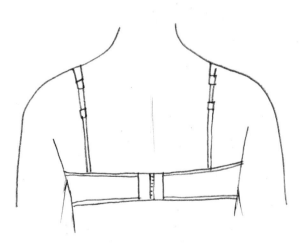

Padded bra

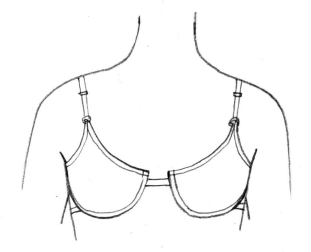
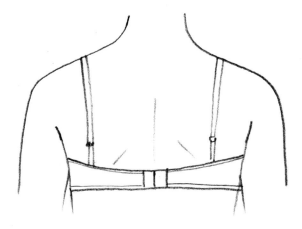

Bra with center gore strap

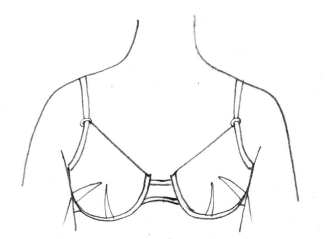
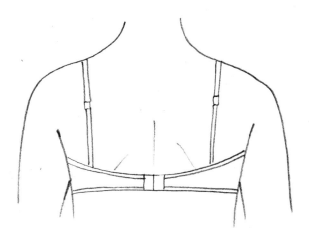

Pleated bra

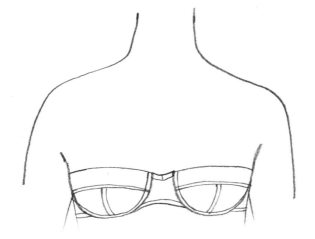
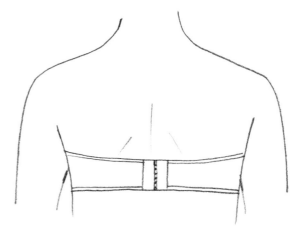

Strapless bra

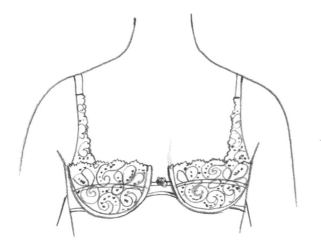
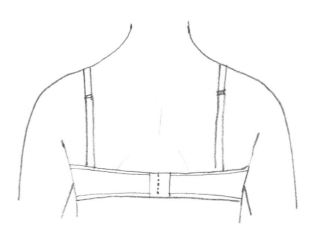

Lace bra

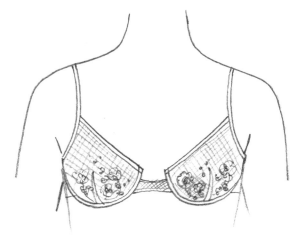

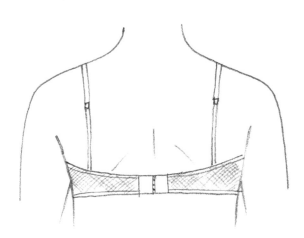

Transparent bra

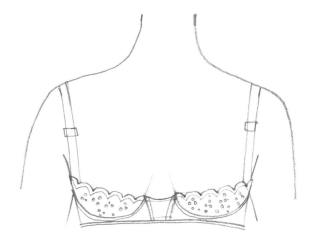

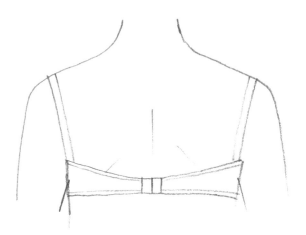

Cotton embroidery bra

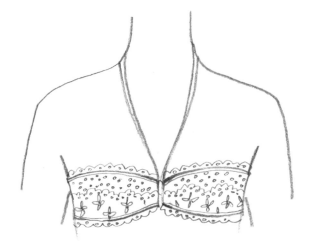
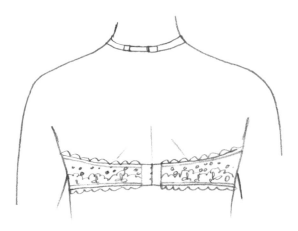

Halter neck bra

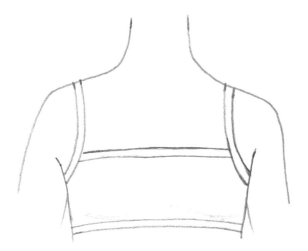
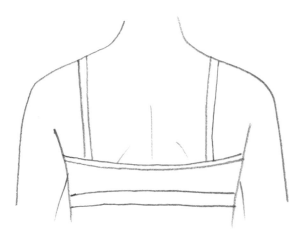

Tube top

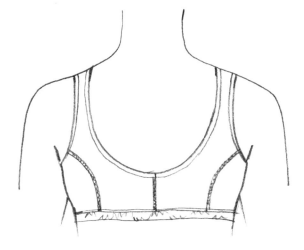
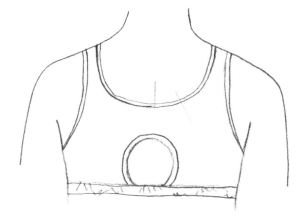

Sports bra

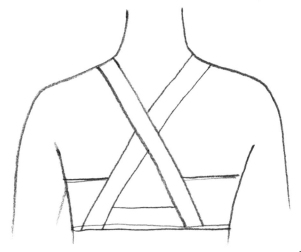
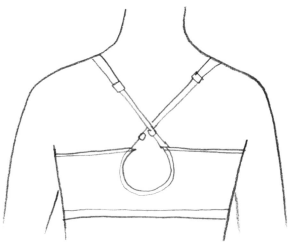

Sports bra, *backs*

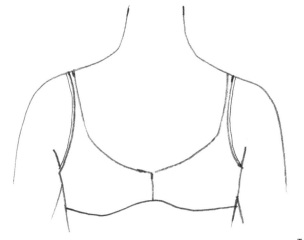
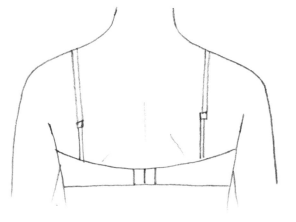

Triangular-shaped bra

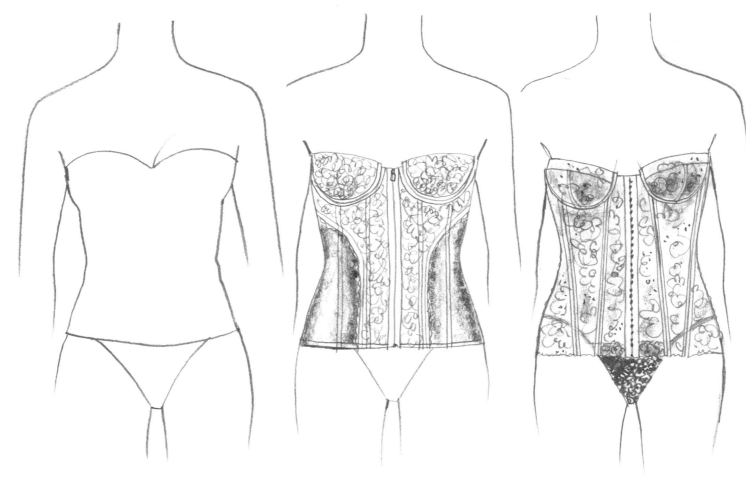

Bra top Lace and satin bodice Transparent lace bodice

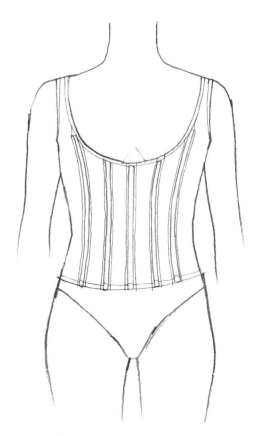

Bodice with rounded neckline

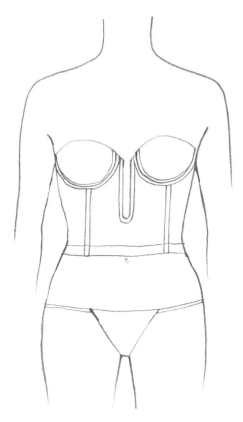

Strapless waist bodice

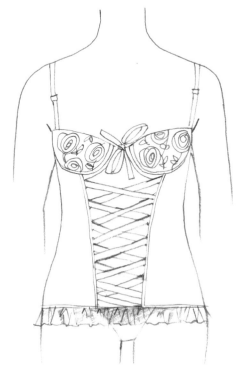

Bodice with crossed laces

Garter belt

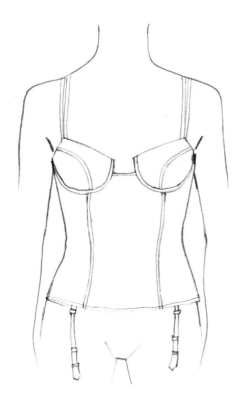

Bodice with garter belt

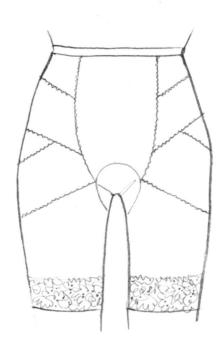

Half-leg girdle

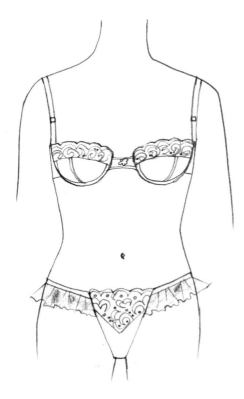

Ensemble of silk lace and tulle

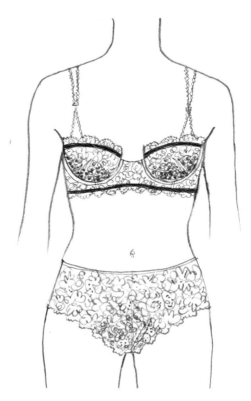

Ensemble of silk lace

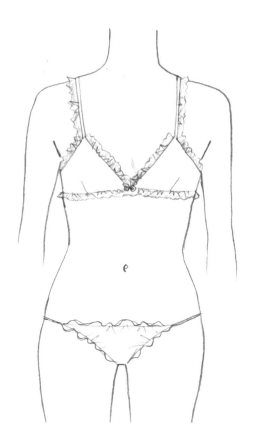

Ensemble of superimposed pieces

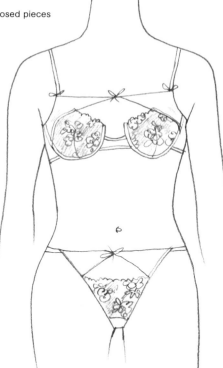

Ensemble of tulle frills

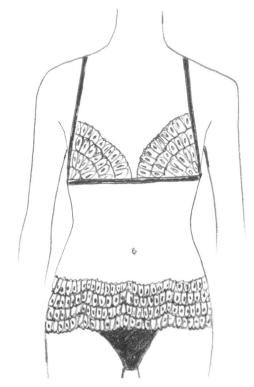

Lace deco ensemble

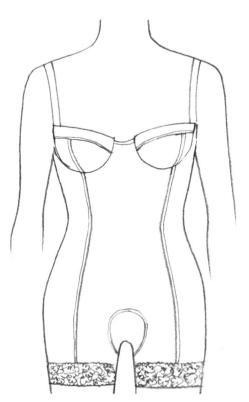

Whole-body girdle

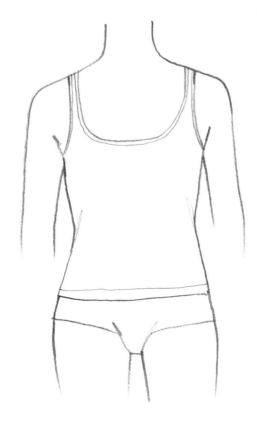

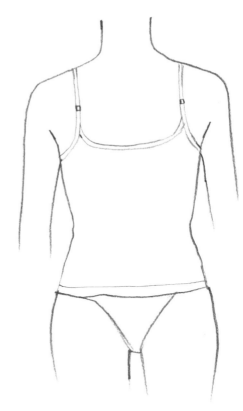

Tops

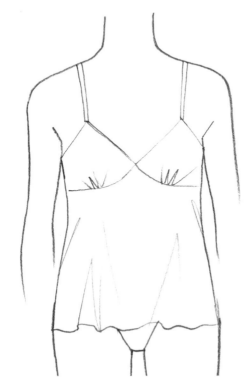

Gathered top

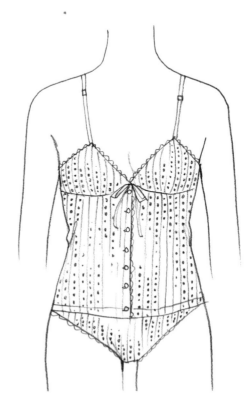

Cotton openwork top

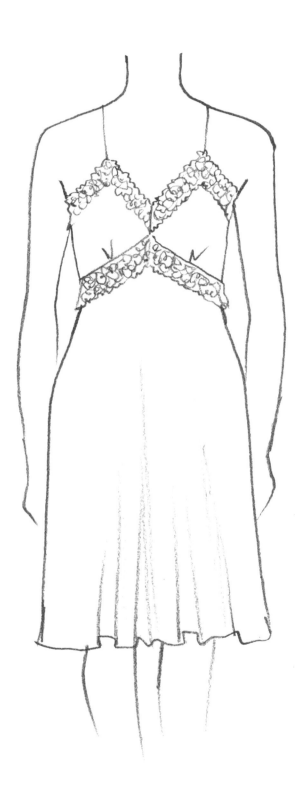

Satin nightgown with 1920s-style lace

Top with slits

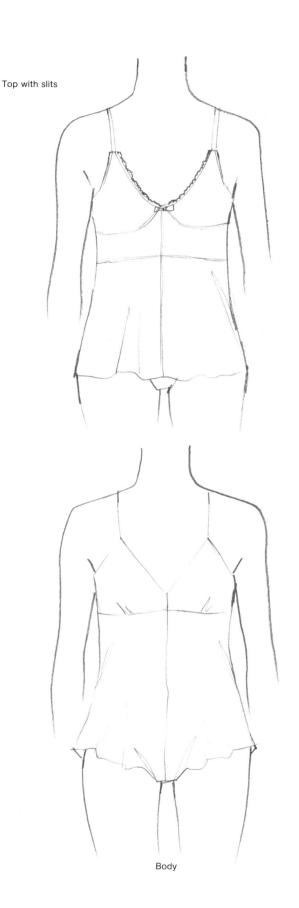

Body

Short 1960s retro nightgown

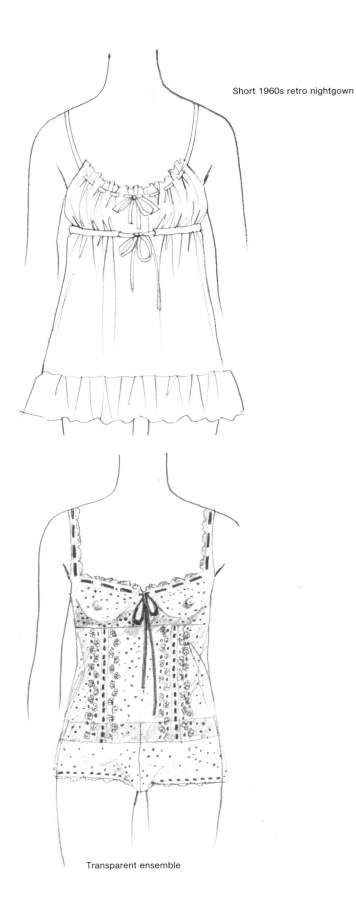

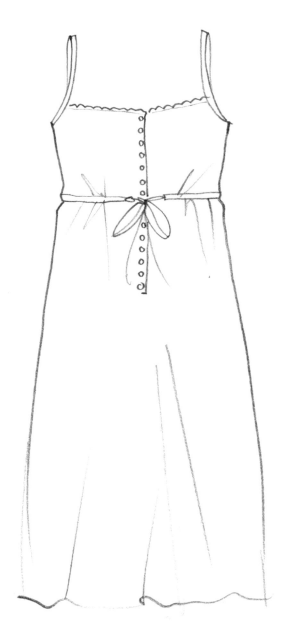

Romantic cotton nightgown

Transparent ensemble

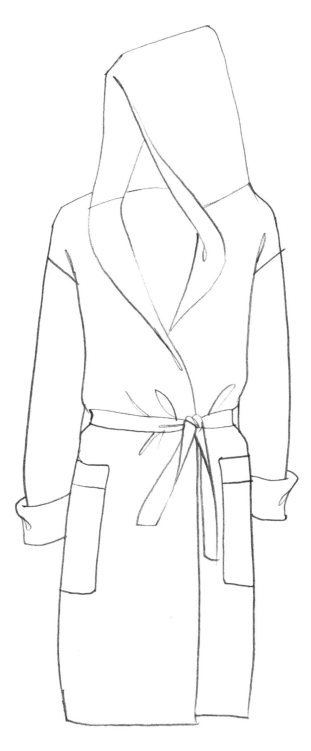

Hooded bath robe

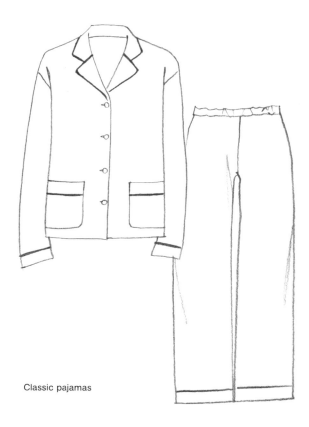

Classic pajamas

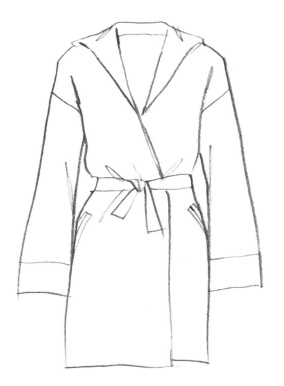

Hooded bathrobe with wide sleeves

Shoes

From above

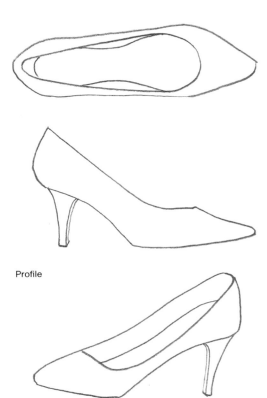

Profile

3/4

Multiple views of classic pump

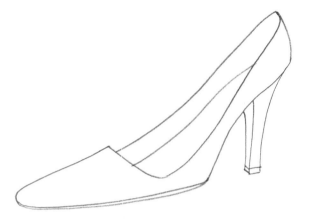

Pump

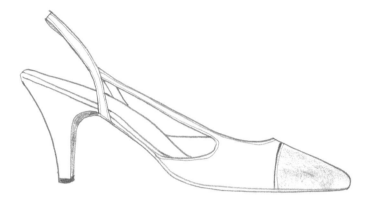

Two-colored slingbacks

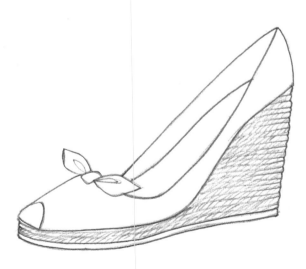

Platforms

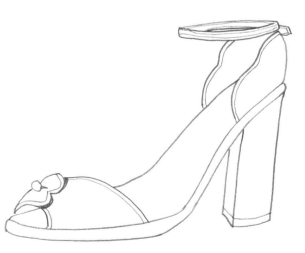

1970s high heel

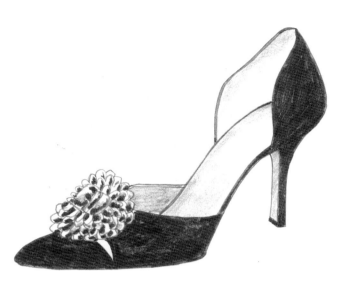

Open sides. Jewel ornament

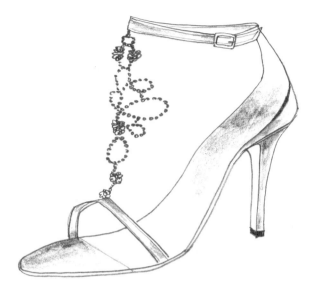

Beaded sandal

Retro perforated pump

With sequins and netted flower

1970s sandal

Evening sandal

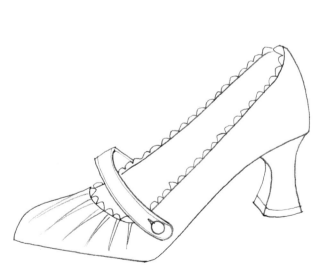

Retro, gathered, and with strap

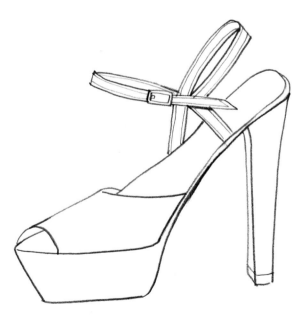

Platform

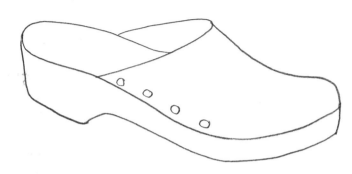

Clog

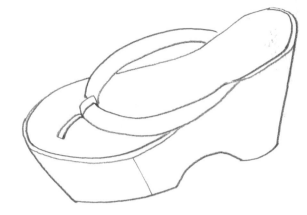

Revived Japanese clog

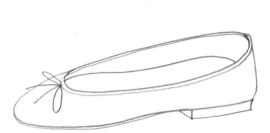

Ballet flats

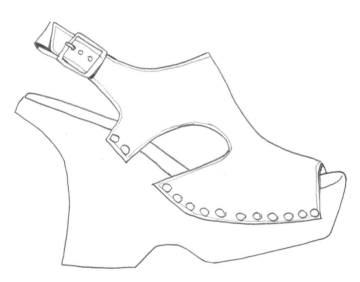

1970s clog

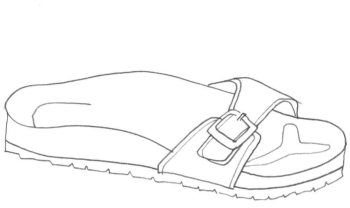

Exercise sandal

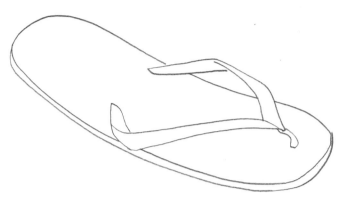

Flip-flop

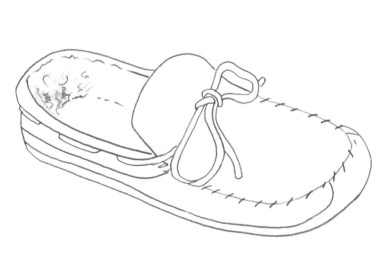

Moccasin

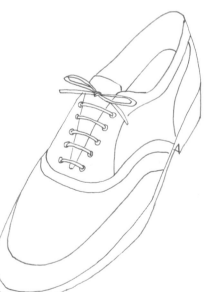

Classic Oxford shoe

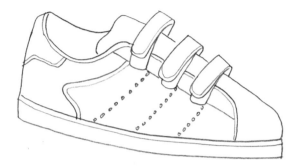

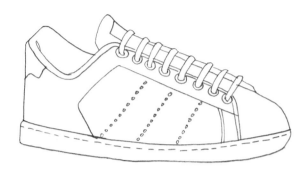

Sports shoe with and without Velcro

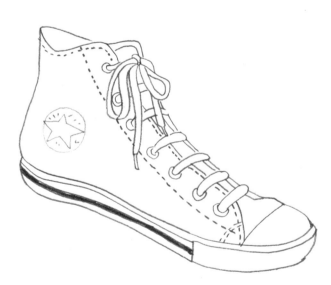

Sneakers

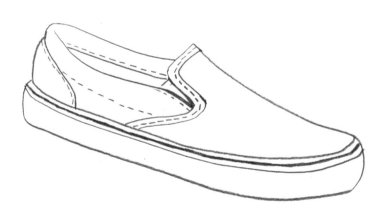

Beach shoe

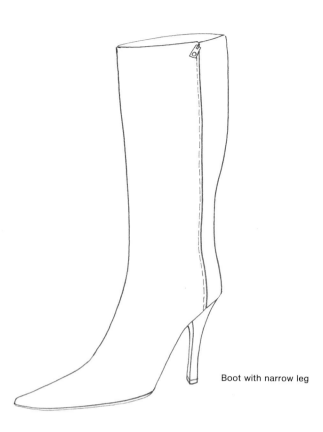

Boot with narrow leg

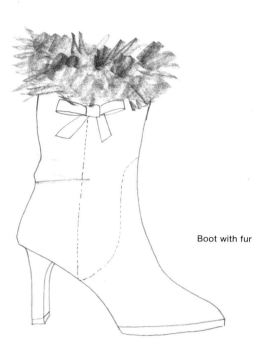

Boot with fur

Cowboy boot

Calf-length boot

Accessories

Industrial bag

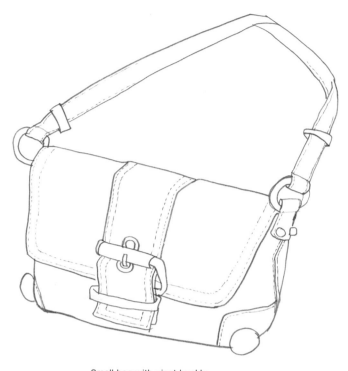

Small bag with giant buckle

Bag with scarf

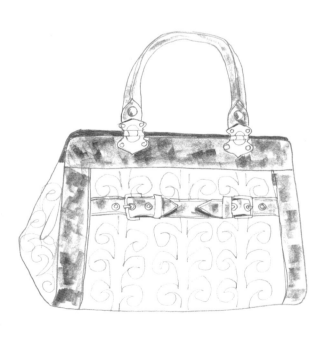

Printed

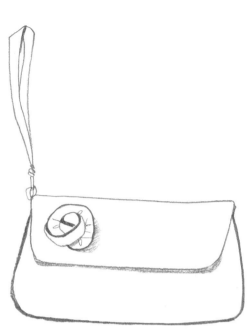

Purse

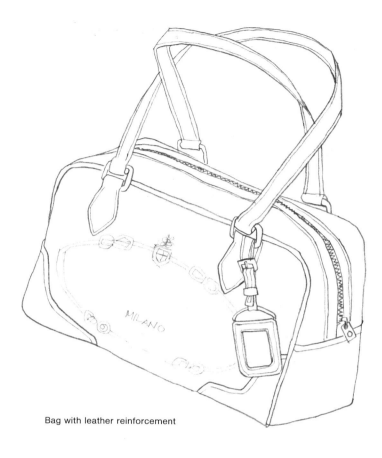

Bag with leather reinforcement

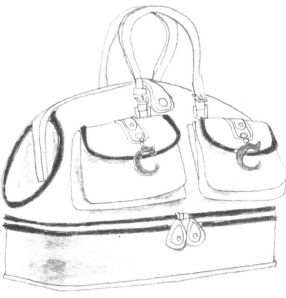

Bag/briefcase with compartments

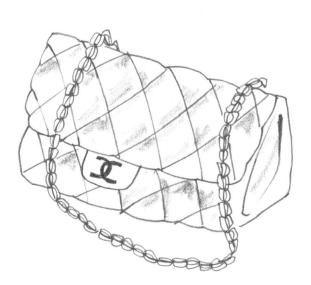

Padded bag

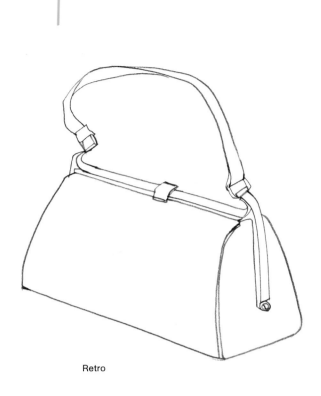

Retro

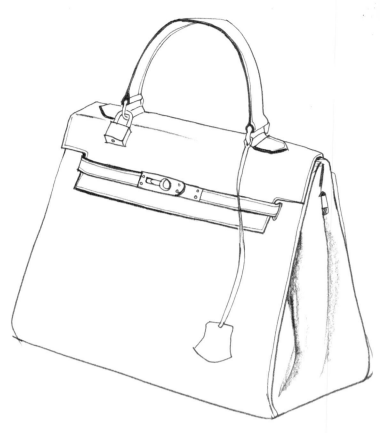

Classic

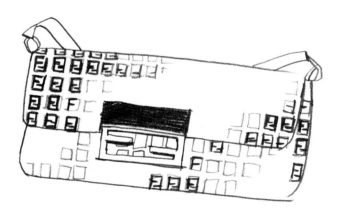

Baguette bag

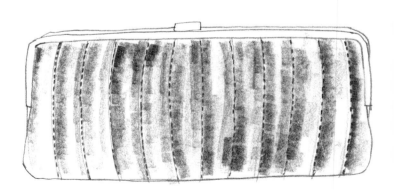

Padded purse

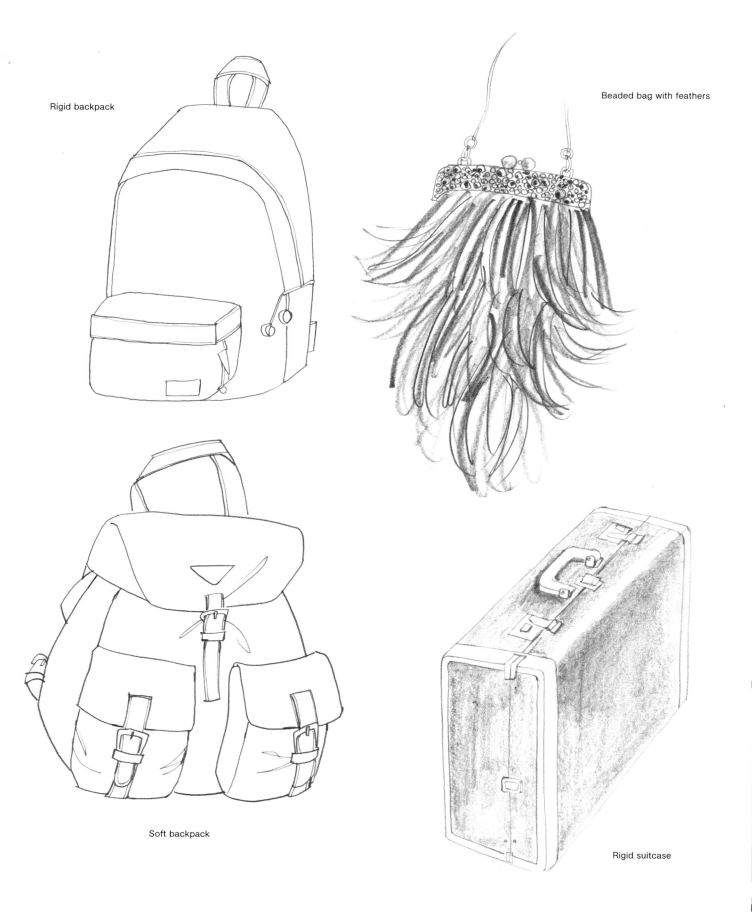

Rigid backpack

Beaded bag with feathers

Soft backpack

Rigid suitcase

169

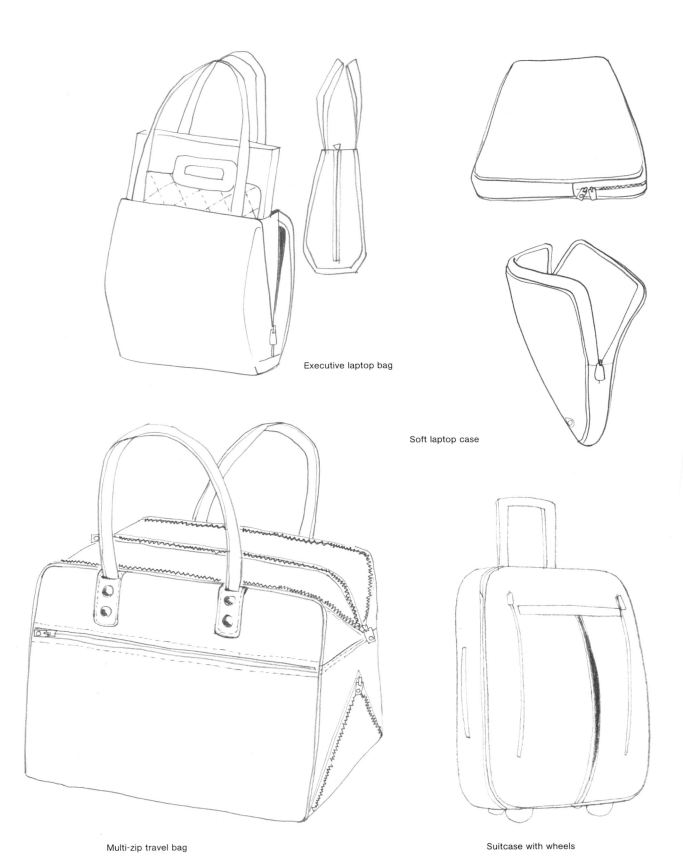

Executive laptop bag

Soft laptop case

Multi-zip travel bag

Suitcase with wheels

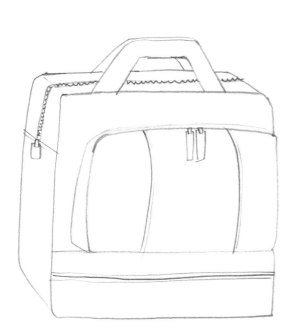

Laptop briefcase

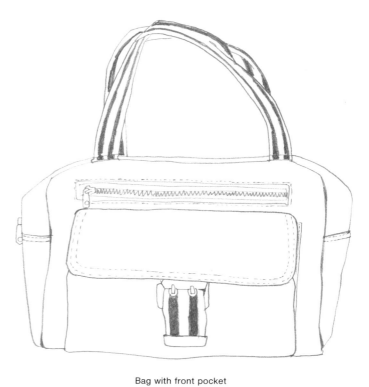

Bag with front pocket

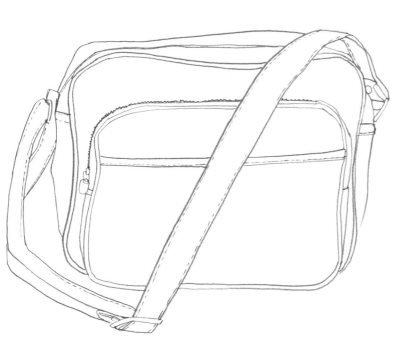

Sports bag

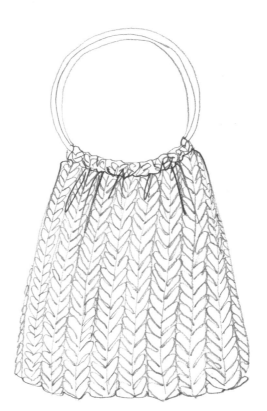

Knitted bag with rigid handle

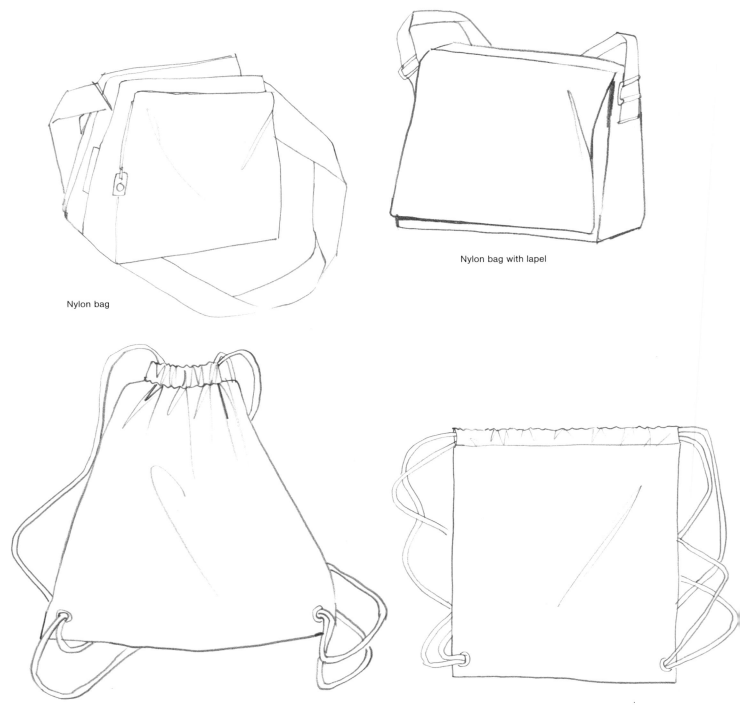

Nylon bag

Nylon bag with lapel

Nylon bag, closed and open

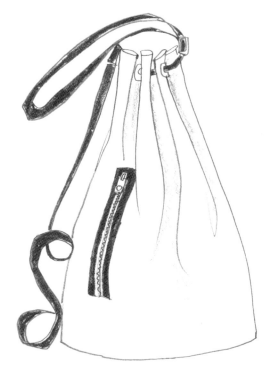

Soft bags

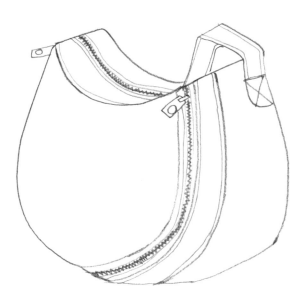

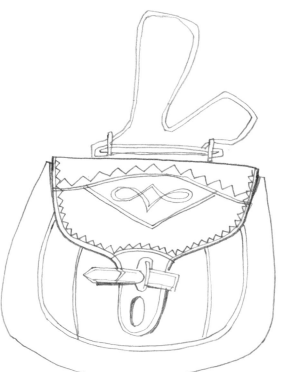

Leather bags

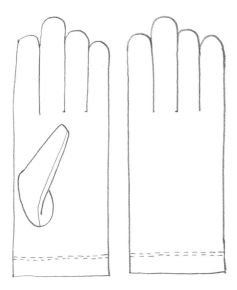

Classic gloves

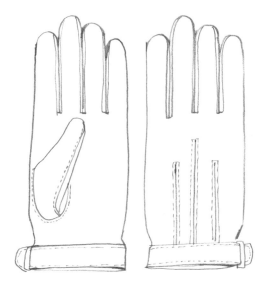

Classic leather gloves

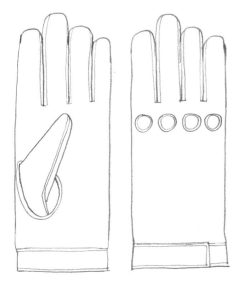

Gloves with perforated Velcro

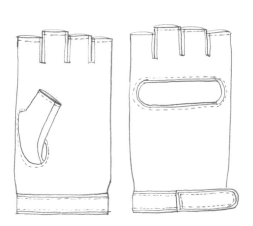

Fingerless Gloves

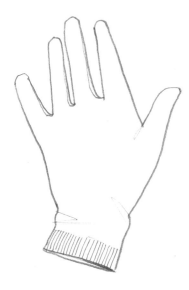

Plain gloves

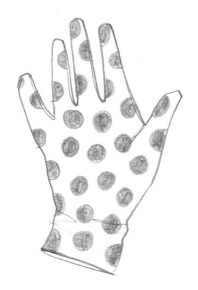

Gloves with prints

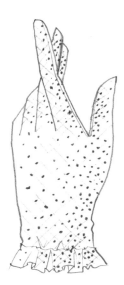

Lace gloves

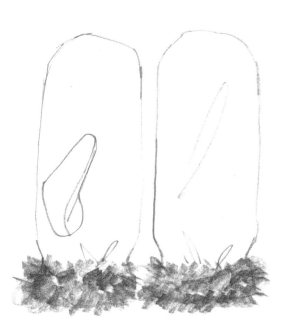

Mittens

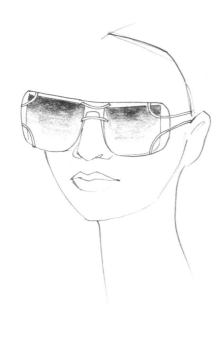

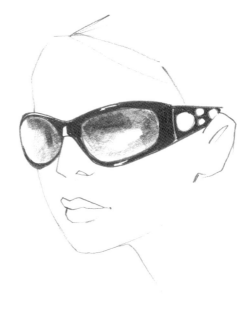

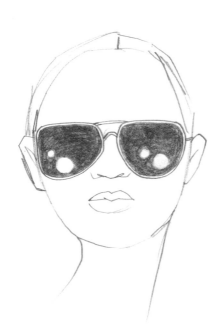

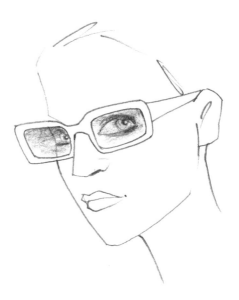

Sunglasses

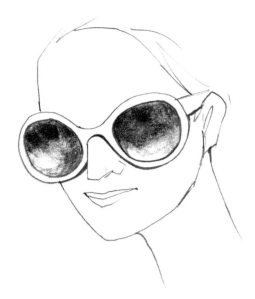

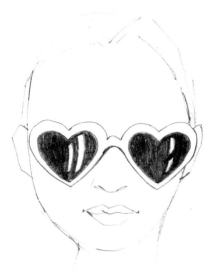

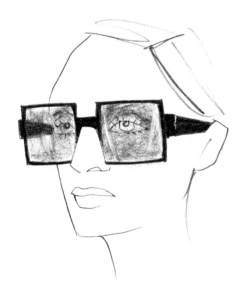

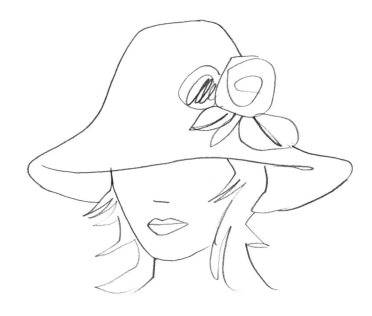

Broad-brimmed hat
with flower

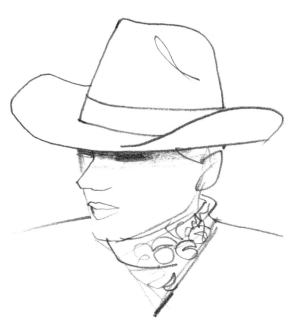

Cowboy hat

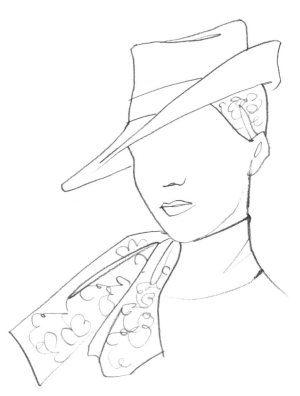

Hat with scarf

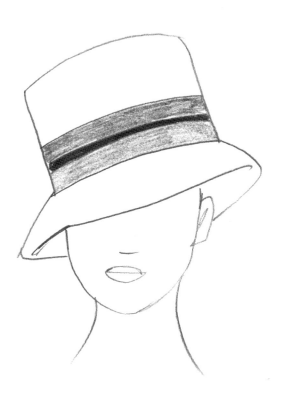

Top hat

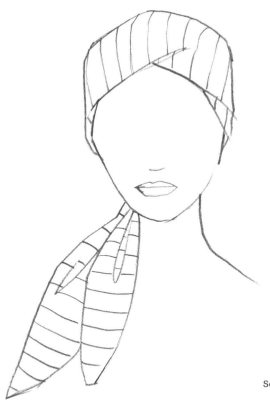

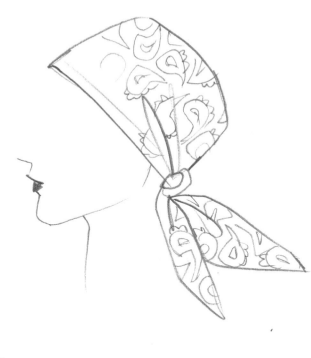

Scarves, *front* and *profile*

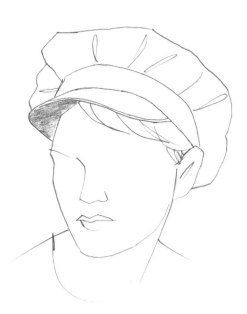

1970s cap

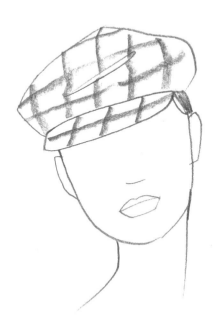

Boys cap

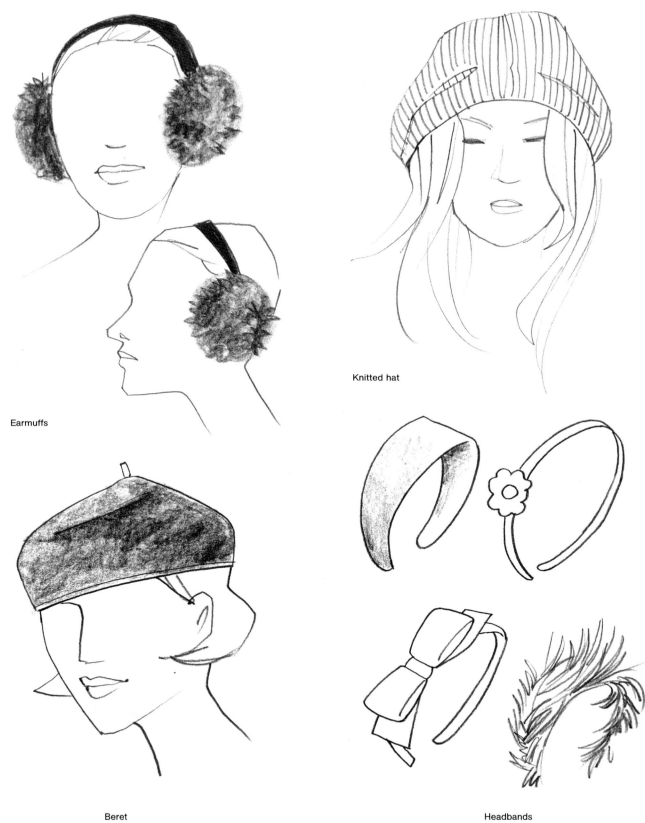

Earmuffs

Knitted hat

Beret

Headbands

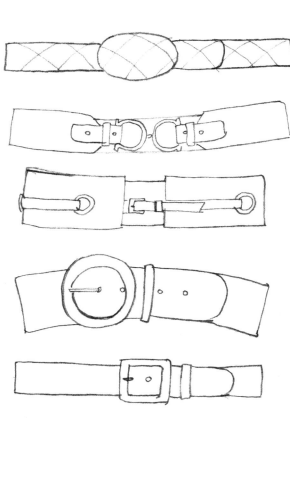

Belts

At waist

At hip

At waist, soft leather

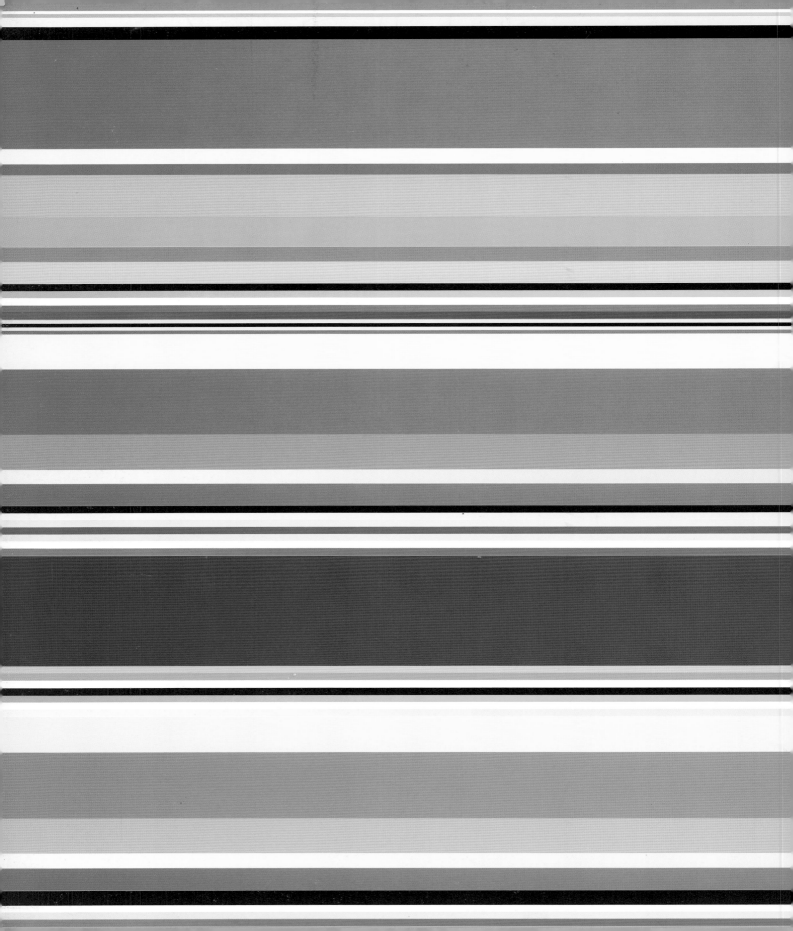